Beryl Bainbridge

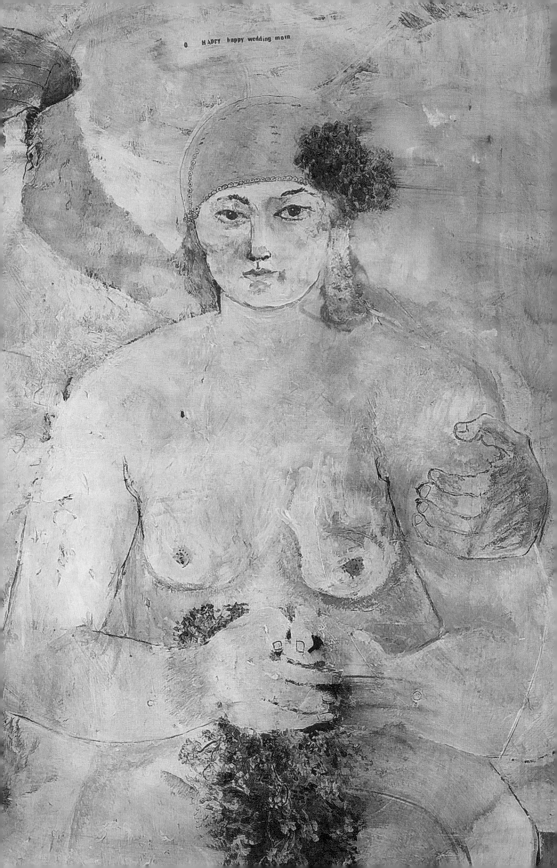

Psiche Hughes

Beryl Bainbridge

Artist, Writer, Friend

With 108 illustrations in colour and black and white

 Thames & Hudson

For Beryl, ever present

Page 2:

Detail from *Oh Happy Wedding Morn* by Beryl Bainbridge.
See page 111.

First published in the United Kingdom in 2012 by
Thames & Hudson Ltd, 181A High Holborn, London WC1V 7QX

Beryl Bainbridge paintings © 2012 The Estate of Beryl Bainbridge
Text © 2012 Psiche Hughes
Preface © 2012 Brendan King

Designed by Karolina Prymaka

British Library Cataloguing-in-Publication Data
A catalogue record for this book is available from the British Library

ISBN 978-0-500-51651-5

Printed and bound in China by C & C Offset Printing Co. Ltd

To find out about all our publications, please visit
www.thamesandhudson.com. There you can subscribe
to our e-newsletter, browse or download our current catalogue,
and buy any titles that are in print.

Contents

Beryl in fur in the late 1980s

Beryl Bainbridge is most popularly known as a writer who first made her name in the 1970s with a string of short, blackly comic novels, such as *Harriet Said* (1972), *The Dressmaker* (1973), *The Bottle Factory Outing* (1974) and *A Quiet Life* (1976). Then, during the latter part of her career, she turned to writing idiosyncratic fictional re-imaginings of some of the most iconic moments in Western history: Scott's failed trip to the South Pole in *The Birthday Boys* (1991); the sinking of RMS *Titanic* in *Every Man for Himself* (1996); and the role of the British in the Crimean War with *Master Georgie* (1998). Although close friends knew that Beryl had another life as an artist, many of those who enthusiastically bought her novels were only dimly aware, if at all, that painting and drawing had been the author's lifelong passion and occupation.

But things could so easily have been different. Established success as a writer came to Beryl only at the third time of asking. Twice her writing career faltered and almost ran aground, and at these times art and painting came to the fore. In the late 1950s, for example, she submitted the manuscript of her first completed novel, *The Summer of the Tsar*, to a number of publishers who, despite recognizing its literary quality, turned it down as unpublishable on the grounds that its subject matter was too controversial. It was not until the mid-1960s that she started to submit work again, and not until the early 1970s that *The Summer of the Tsar* was published under the title *Harriet Said*. Following the departure of her painter-husband Austin Davies in 1958, four years after she married him, she turned to painting not just as an alternative means of expressing her creative side but as a more

practical way for a single mother, with two young children to support, to make ends meet.

> I've been lucky in that my paintings have sold well; they did even before I became known as an author. At first, I couldn't bear any of them going, because I liked them so much, but it became so lucrative, and I needed the money.[1]

If a gallery had expressed any interest in her work during this period, Beryl would perhaps be known today as a painter who also wrote, rather than a writer who also painted.

A similar opportunity occurred almost ten years later when Beryl was dropped by her publisher, Hutchinson, after the lacklustre sales of her first two novels, *A Weekend with Claud* (1967)[2] and *Another Part of the Wood* (1968). The poor critical response to her early work and the publisher's subsequent rejection clearly knocked Beryl's confidence, as she later remarked to Shusha Guppy in an interview for *The Paris Review*:

> I wrote my first novel, *A Weekend with Claud*, and sent it to what was called in those days New Authors Limited, which was an offshoot of Hutchinson Publishers, and they took me on. But they only published first books, so when the following year I produced a second novel, *Another Part of the Wood*, I was taken into the big firm – Hutchinson's proper. I thought I'd walk down the street and everybody would know I had written a book. But nobody took any notice of these two novels, and I stopped writing. I felt uneasy for about three years.[3]

This temporary setback to her literary career also affected her bank balance: 'I thought when I was published that I was set up, but I made about £25 from *Claud*,'[4] she later complained to an interviewer. Once again, art filled the creative – and financial – void, and the sale of drawings and paintings, whether to friends or through sporadic exhibitions, helped to bring in some extra money. As she enthusiastically confided to the journalist Alex Hamilton, painting could be a profitable business if you were willing to compromise on the price: 'They sell like absolute hot cakes if you only ask £25.'[5]

During this period Beryl produced some of her most striking portraits of friends and acquaintances, and in a vibrant creative interlude between 1969 and 1970, spent at Eaves Farm in the Pennines with the painter Don McKinlay, she experimented with artistic techniques that were new to her, such as etching and engraving. A series of images resulted, many of which featured a symbolic figure who recurred in her art: Napoleon. 'I was fascinated by the fact that he had led this very worldly life,' she explained, 'and was then confined to St Helena with all these ladies cavorting on the rocks.'[6] Aside from the Napoleon series, other emblematic figures also frequently featured in her paintings and drawings of the 1970s:

> Captain Dalhousie formed another series. I've no idea who
> he is – just a name that came into my head. There's Captain
> Dalhousie getting married and Captain Dalhousie at the
> Front. Then I did a series of wedding groups with all the
> guests beautifully dressed. But the groom was wearing only
> a top hat and the bride only a veil. The pictures were painted
> in the form of a group photograph and only the camera knew
> they hadn't any clothes on. I also did a series of the Queen
> Mother investing people with medals. There again, everybody
> in the background was in full uniform except the poor man
> who was getting the medal – he was only wearing a hat.[7]

Although Beryl had some success in selling her work in various exhibitions held around this time, once again the world of art lost out to literature. An influential gallery in Mayfair offered to give her an exhibition but the timing was poor: by the early 1970s her writing career was just beginning to gather momentum and she felt she had to decline the offer.

It was following an accidental meeting in the autumn of 1970 with Colin and Anna Haycraft, who were on the lookout for new writers for their Duckworth fiction list, that Beryl was once more drawn back into the literary world, even though this meant packing books for distribution for a short time. Anna told Beryl that she had read her published novels and didn't think they were much good, but nonetheless she asked if Beryl had written anything else. By chance, the manuscript of *The Summer of the Tsar*, which she had presumed lost, turned up in the post the following year. It had lain untouched in a drawer for a few years and was returned to its

owner after a literary agent had sold his business. The novel that had been considered, according to one publisher's report, 'repulsive beyond belief' and 'too indecent and too unpleasant even for these lax times',[8] was just the thing the Haycrafts were looking for. This time, with the new title of *Harriet Said*, Beryl found the literary success that had eluded her for so long. To a certain extent literature's gain was art's loss, but despite the demands of a full-time writing career, she still managed to experiment with her art and produce work that was every bit as distinctive and individual as her fiction.

During the latter part of her life, Beryl took to painting as a complement to her writing, producing several series of pictures based on her historical novels. A sequence of paintings from the early 1990s depicts Scott and the Antarctic expedition, following the publication of *The Birthday Boys*; images of the RMS *Titanic* were completed between 1996 and 1998, after *Every Man for Himself*; and, between 2001 and 2003, her paintings feature Doctor Johnson, following the completion of her novel about his relationship with Mrs Thrale, *According to Queeney* (2001).

*

Beryl was born in 1932 and brought up in Formby in Lancashire, by the coast. Richard Bainbridge, her father, was a self-made man from Liverpool. Having achieved a certain success in business, he had wanted his family to grow up away from the working-class streets of Liverpool where he had spent his youth. Beryl's mother, Winifred (Winnie) Baines, saw herself as a respectable middle-class woman – she had grown up in a suburban villa in west Derby and attended a finishing school in Belgium.[9] Beryl's family members knew their station in life: if they weren't exactly 'higher than the angels...we were up there with the vicar and the doctor and the schoolmaster'.[10] The financial crash of 1929, however, had a disastrous impact on the family, exacerbating Winnie's class insecurities and undermining Richard's self-esteem and image of himself as a successful man:

> He married late in his 40s and when he was in what was
> referred to as 'a good way of doing', meaning he was
> financially secure. And then the gold standard fell, there

was a slump and he was made bankrupt, something that in those long-gone days was considered shameful. My parents lost their big house on the Wirral, in Merseyside, and by the time my brother and I were born he was reduced to being a commercial traveller, going from house to house with a suitcase.[11]

Winnie became acutely sensitive to any embarrassing reminders that the Bainbridge family circumstances had been anything other than comfortable. Once, when Beryl told a school friend that her Auntie Nellie and Auntie Margo were poor, she recalled that her mother 'nearly snapped my head off, and said it wasn't nice to use that word'.[12]

Richard Bainbridge's bankruptcy left him feeling humiliated and prey to violent mood swings, which badly affected his personal relationship with Winnie. She resented the decline in the family's fortunes, and during acrimonious arguments with her husband she would accuse him of being a failure. As a child caught in the middle, Beryl was always having to tread carefully so as not to aggravate the smouldering tensions between her mother and father:

> It was terrifying. My mother had married my father when he was a rich businessman and they could afford a big house and a maid. Then a year later it had all gone, and she felt cheated. My father had terrifying rages, never hitting anybody physically – never – but verbally atrocious. He was schizophrenic: normally a charming and lovely man, he became a monster when the rages came. My first job when I came back from school would be to put the wireless on to drown out the noise so that the neighbours wouldn't hear. The rages would last two to three days and be followed by three months of sulking, during which I had to ask for money every Saturday morning to buy food. We used to put his food in a bowl at night and leave it outside his door, like an animal.[13]

Such conflicts may have made home life stressful to a young child, but it also had the effect of sharpening the future novelist's eye for eccentric

behaviour and subtle shifts of emotional mood. 'I didn't write fairy stories and that sort of thing,' she once told an interviewer about her childhood fiction. 'I was writing subversively about my background all the time but changing it...I was writing about what was going on in the house and disguising it as much as possible.'[14] In later years, Beryl admitted that writing semi-autobiographical fiction was a way to make sense of her childhood experiences: 'If it had not been for writing, I'd have ended up a total neurotic. I only wrote to get out this business about my mum and dad...it was marvellous therapy.'[15]

Beryl's initial interest in art was intimately linked to her desire to write. She illustrated the novels and stories she wrote as an adolescent, as well as the notebooks and journals she kept. She even illustrated a rude poem that a school friend had given her, for which she was expelled from Merchant Taylors' Girls' School at the age of fourteen. As with her writing, she was motivated in her painting and drawing by a similar fascination for plot and narrative: 'I used to draw people and houses a lot, but always with a story.'[16] This emphasis on stories was encouraged by her father, who one day returned home with a complete set of the works of Dickens, picked up from a travelling salesman, which he would read aloud to her.[17] Although her parents were not particularly interested in art, they did not dismiss the creative impulse:

> I can't say that my parents were actually artistic themselves
> – all I seem to recall my father drawing is a tulip once,
> which was absolutely dreadful – but they were encouraging
> when I started playing with paints and bits of paper around
> the age of 14.[18]

At this stage, Beryl's interest in painting was purely personal and she had no thought of going to art school or seriously taking up art:

> I've always painted – painted with anything I could find:
> oils, house paint, anything. I just liked it. I've had no formal
> training and can't remember any members of my family
> painting, but I often used to go to galleries.[19]

A well-intentioned elderly lady called Mrs Criddle took her to the Walker Art Gallery in Liverpool and introduced her to concert halls, live theatre and

the Socialist movement. Beryl recalled visiting an art gallery in Southport at the age of thirteen, where she saw her first paintings by Fra Filippo Lippi. She often referred to Lippi as one of her favourite painters and attributed the first stirrings of her youthful interest in Catholicism to his pictures: 'Though I later read *The Heart of the Matter* and *The End of the Affair*,' she remembers, acknowledging the influence of Graham Greene, 'neither book had the same shattering effect on me as had Lippi and his hang-dog saints with those fanatical eyes whose gaze reminded me of my father.'[20]

Beryl was drawn to artists whose work exhibited a kind of painterly exuberance: she liked the elongated forms of El Greco and Amedeo Modigliani, and the expressionistic use of paint in Paul Gauguin, Vincent van Gogh, Walter Sickert, Georges Rouault, Marc Chagall and Francis Bacon. But she was also attracted by the myth of the artist, and the stories of their lives often had more significance than their formal or stylistic technique:

> At one stage, I particularly liked van Gogh. But somehow,
> when an exhibition of his paintings came to Liverpool,
> I was extremely disappointed; they all seemed so small.
> With painting, as in writing, I've always been more interested
> in the life of a person who does something, rather than what
> they actually do. All that stuff about van Gogh cutting off
> his ear and Modigliani drinking himself to death on absinthe
> I find fascinating. And I believe that Rouault, whom I also
> particularly admire, had a pretty tragic time.[21]

Beryl had her first real introduction to the practical world of fine art in the early 1950s through another art form – that of the theatre. During her period as an assistant at the Liverpool Playhouse (now the Everyman Liverpool Playhouse), she met Austin Davies, an artist and lecturer at the Liverpool College of Art who had been drafted in to paint scenery at the theatre, and whom she married in 1954. Austin was a well-respected painter in his own right and his portrait of Beryl from this period, *Portrait of the Painter's Wife*, was purchased by Manchester Art Gallery. Austin's influence on Beryl was considerable, not only as an inspiration and a source of knowledge about the techniques and practices of painting, but also through his connections at the college. It was through Austin that Beryl came into contact with other contemporary Liverpool painters, including

Portrait of the Painter's Wife by Austin Davies, late 1950s
(purchased by Manchester Art Gallery)

Don McKinlay, Fanchon Fröhlich and Yankel Feather, as well as two future members of The Beatles, John Lennon and Stuart Sutcliffe, who were Austin's students at that time.

Another significant encounter came shortly after Beryl's move to north London in 1963, where she met the couple Psiche Andrews, a language teacher, and Philip Hughes, an artist. In the years before Beryl found success as a writer, when she was still struggling to cope as a single mother and money was hard to come by, Psiche and Philip would introduce her to their friends and urged them to buy her paintings. They also introduced her to other artists, such as the painter Keith Grant, who helped organize charitable exhibitions on behalf of the Medical Aid Committee for Vietnam at Hampstead Town Hall during the early 1970s. Beryl exhibited there, alongside David Hockney and Eduardo Paolozzi.

Like Henry Miller, whose serious work as a writer was paralleled by an enthusiastic love of painting, Beryl found painting a more relaxing occupation than writing:

> What I love about painting as opposed to writing is that it
> is so instantly fulfilling: it gives one such a happy, carefree
> feeling. When you're painting you can watch telly, walk
> around, eat; whereas when you're writing...God! You have
> to keep puzzling the whole thing over and really bloody well
> work at it.[22]

Her preference for art as relaxation was the inevitable result of the steady increase in her reputation as a novelist during the mid- to late 1970s and the pressure of a full-time writing career: 'Once you get so-called professional at something, I think a lot of the fizz goes out of it.'[23] Her more relaxed attitude to painting contrasts with a persistent anxiety over writer's block, a condition that would increasingly bear down on her during the last decade or so of her career, when her output slowed from practically one book a year during the 1970s to two or three a decade during the 1990s and 2000s. She never experienced a fear of a blank canvas or the anxiety that material for her painting would eventually run out:

> When I was turning out about 20 to 30 oil paintings a year...
> I never thought, once I'd finished one, that I'd never be

able to paint another as good. It never occurred to me. But
with books nowadays I do think, after I've completed one,
'How will I ever start another?' and get absolutely panic-
stricken. You can't buy words in a shop, I suppose, like you
can artists' materials.[24]

This relaxed attitude is everywhere visible in Beryl's art, from her use
of everyday objects and materials, such as paper doilies and photographs
cut from books and newspapers, to her lack of concern over the strict rules
of perspective or technical proficiency. The result is a series of paintings
and drawings whose style is unmistakable and unique. Although she sold
a number of paintings early in her career, she remained an amateur painter
in the best sense of that word, producing pictures without any sense of
obligation to compete in the professional world of art or conform to its
rules. Again, as in Henry Miller's art, there is a naivety and modesty in
Beryl's attitude to painting that is characteristic of the private person she
was, rather than the literary celebrity she became:

Of course it is always a danger, when you begin to sell a lot
of paintings, that you will get to thinking you are good.
And yet I know that whereas if I got a bad book review
in a newspaper it would hurt very much, on the other hand
if someone who knew a lot about art, a real painter, came up
to one of my paintings and said, 'That's bloody awful,'
I don't think I really would mind that much. In fact, I think
I'd probably agree with him.[25]

Brendan King

'Writing was more beneficial than attending a psychiatric clinic'

As far as I know, Beryl did not paint a portrait of her father. There is, however, an ink drawing from 1975 of her mother, Winifred (known to the family as Winnie), which Beryl did when living in Albert Street, Camden, north London. By then I had known Beryl for twelve years. We first met in the summer of 1963, when she moved into the flat above mine in a big old-fashioned Edwardian house in Arkwright Road near Hampstead Heath, north London. She arrived with her children and an assortment of luggage, including paintings, unpublished manuscripts and pieces of furniture (memories of her Liverpool home, which feature in her work). We were both divorcees, each with two children, although mine were older than hers and I was about to marry Philip Hughes whereas Beryl was single. We found we had a lot to talk about: the children, our love lives (past and present) and gossip. She told me she had recently moved to London from Liverpool, mainly motivated by concerns for her children's education: 'Quite wrongly, I thought schooling would be better in London.'[1] But she remained very attached to her home city: 'I am so tied to it by the past, by memories of family and beginnings, that I still think of it as home.... If an uprising broke out in Liverpool...I should rush to the barricades.'[2] She may have exaggerated, but it is true that Liverpool held a firm place in her memory and she returned from time to time. We went there together for the opening of the new Tate in 1988 and stayed in the Adelphi Hotel, which she fondly remembered for its Roman baths in the basement and posh teas served on the ground floor.

The title for the portrait of Winnie – *My Mum when younger, singing with a proper orchestra and a conductor with lovely white hair. So distinguished.*

– illustrates the subject's flirtatious nature and innocent vanity. She was very sociable and loved to shine in company. Perhaps she was like the main character in *Mum and Mr Armitage* (1985): 'Not that she was motherly – far from it. True, she was well built, but they all agreed that the twinkle in her coquettish eyes was neither matronly nor maternal.'[3] In the painting Beryl captures the essential features of her mother – her ambition and desire to be admired – created with an ironic smile, certainly, but also with tenderness.

Beryl once told me that not a day went by when she did not think of her mother. Yet, whenever Winnie came to London, Beryl viewed the visit with dread and found her presence irritating. Theirs was a strange relationship, based on disapproval from one side and rebellion on the other. These antagonisms dated back to childhood when her mother wanted everything to be proper (and Beryl was far from proper); so much so that she even insisted on her daughter having curls and gave her a perm against her will. Beryl also had to have elocution lessons, but she remained grateful for these, advocating that everyone should have them.

Winnie looked down on her husband, especially after his business failed and the family became short of money. She refused intimacy with him, Beryl once revealed: he was only allowed to scrub her back on Saturday afternoons during her weekly bath. In an interview with Lynn Barber, she was more explicit, recalling how her father had shouted angrily at her mother, and how she and her brother had been terrified by his fits of rage: 'He was never physical, he never hit her, it was just these voices downstairs.'[4] These scenes of domestic disharmony form the backdrop to *A Quiet Life* (1976), and also constitute a theme that runs through some of her other books. After she wrote *According to Queeney* (2001), which describes relations between literary figure Doctor Johnson and his friend and admirer Mrs Thrale, she said that her original inspiration came from a letter in which Queeney, Mrs Thrale's eldest daughter, declares that their mother's 'original and persevering dislike of her children arose from hatred of our father'.[5] This novel is as much about the stresses of married life as it is about the historic relationship.

To escape the atmosphere between her parents at home, Beryl Bainbridge took to writing at the early age of eight. In the introduction to *Filthy Lucre* (her first attempt at a full-length novel, which was eventually

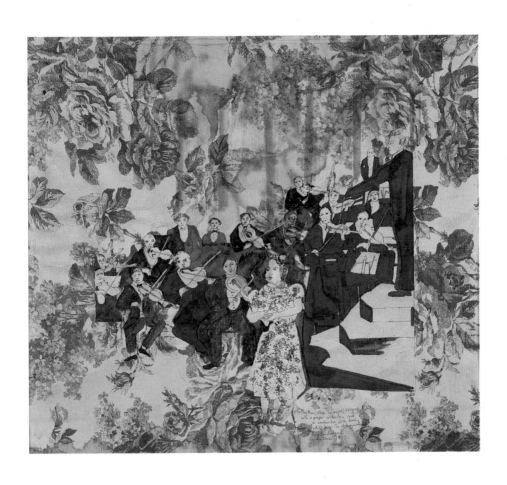

My Mum when younger, singing with a proper orchestra
and a conductor with lovely white hair.
So distinguished. 1975

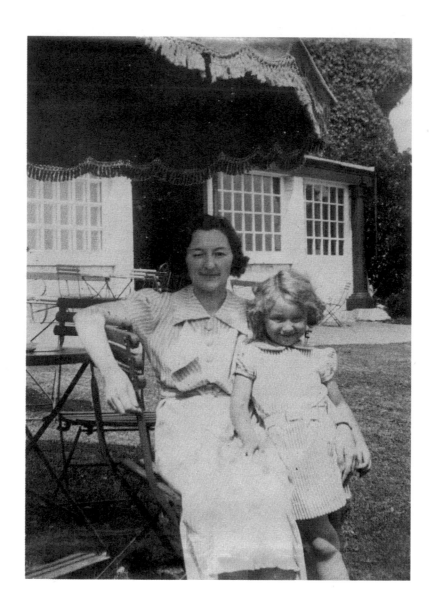

Beryl with her mother, late 1930s

Beryl with a perm, early 1940s

published by Duckworth in 1986) she describes writing short stories such as the tale of an old sea dog, Cherry Blossom Bill, 'who kept his rum supply in his wooden leg'.[6] It was in 1946, at the age of thirteen, that she started writing *Filthy Lucre*, a highly moralistic adventure story. 'Writing was more beneficial...than attending a psychiatric clinic,' she explains, adding that it 'helped to get rid of anxieties nurtured by the particularly restricted sort of upbringing common to lower-class girls in wartime England.'[7] And her mother encouraged her: she believed Beryl should become famous, whether on the stage, as a writer or in society.

Beryl says that *Filthy Lucre* 'owes a lot to Dickens and Stevenson',[8] whose work she was reading at the time. She illustrated the original text with drawings, which became too frail to reproduce, but she did create up-to-date versions of the originals for the publication. These drawings confirm that from the start she coupled the written word with the visual image, and reveal her budding artistic talent, which grew with the years alongside her career as a writer. The drawings share imagery with paintings completed in her maturity. For example, *Old Andrew took up his favourite stance* shows a man standing on top of a pile of books underneath a beaded chandelier, just like the one she had in her London home in Albert Street (and possibly added when she reworked the drawings). The rickety three-legged table is another feature common to her later paintings, as is a view from a window; she liked to frame scenes around a window, like Vermeer. *'Shut the window,' said Fanny sharply, and he did* also shows an upholstered armchair, a table with a lamp, an open window crossed by a tree branch and the moon shining out of the dark.

A macabre humour, which pervades this book and is a foretaste of her later blackly comic novels, is apparent in the cemetery scene *He feverishly turned the old man over*, showing tombstones, winged angels and a startled-looking man in a check suit lifting a corpse from its coffin. The same humour can be seen in the drawing that accompanies the story of Trevelian and his men sinking into a bog as they chase after Richard, the hero of the story.

Beryl's style at that age shows a naive, almost Blakean, grandiosity: 'people of England and Wales this does happen in these satanic years when justice is set upon by the strong body of Gold',[9] and attempts a personal version of an avant-garde language: 'Ernest got to his polished feet.

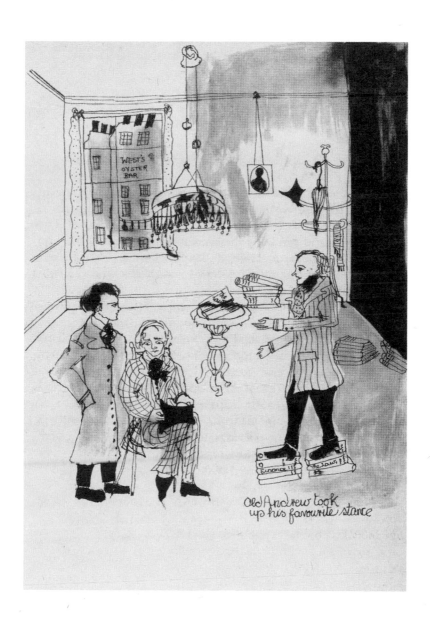

Old Andrew took up his favourite stance, 1986

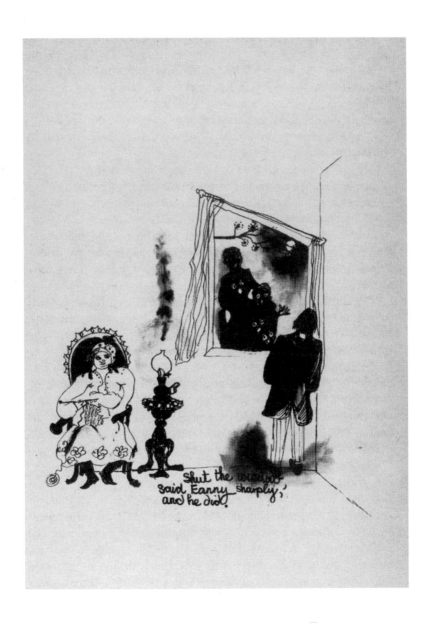

'Shut the window,' said Fanny sharply,

and he did, 1986

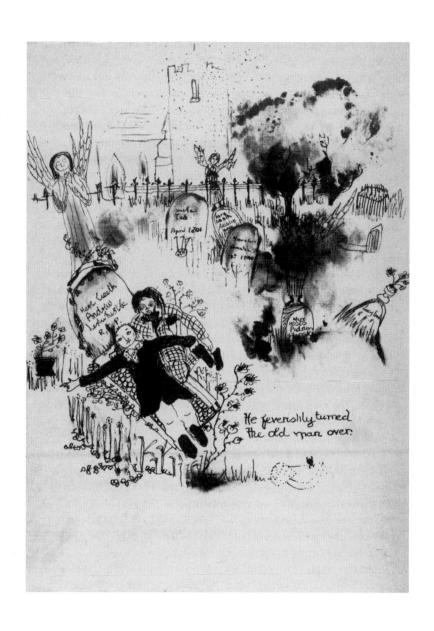

He feverishly turned the old

man over, 1986

Facing him was a ballistic young man in a brilliant red check coat and tails,'[10] and 'fiery demons with sharp-pointed darts of hate attacked'.[11] Beryl's love of words and concern for rhythm in each phrase is already in practice.

Once we'd become firm friends, Beryl talked often about her early influences and developing work, letting me into the secret world of her imagination. She was clear that when writing she refused to read fiction on principle, so as to avoid influences of style and subject matter. But she enjoyed our literary discussions and even shared insights into the process of writing her novels, occasionally honouring me by asking my opinion on a particular detail in an embryonic plot. These were unforgettable conversations that normally took place in the car as we were driving to have our hair 'done' by our regular hairdresser Mr Howard – a six-weekly ritual that continued even after his salon relocated to Bishop's Stortford in Hertfordshire. Beryl never missed an opportunity to comment on my bad driving.

On one or two occasions, if I failed to make an appointment on time, she would send desperate messages about the state of her hair, urging me to do something: 'I keep putting on "Hint of a Tint" and chopping my fringe. I tried to ring you but you must have been away.'[12]

Her reading list was unsurprisingly idiosyncratic. As a child she devoured the nineteenth-century classics. She talked of Trollope and especially Dickens, whom she considered the great master. She shared this passion with her friend and fellow writer A. N. Wilson, who recalls mutual walks 'in Bayham Street, imagining the child Dickens walking down from there to his humiliating work in the boot-blacking factory in the Strand when he was a child of 10'.[13] She loved historical novels, including those by Walter Scott, and they possibly inspired her in later work to dramatize epic events such as the 1910–12 Antarctic expedition and the sinking of the *Titanic*.

Beryl's anti-hero was the figure of Long John Silver and she referred to Stevenson as the inspiration of her very early writings. Later in life, she was fascinated by the language of *Our Lady of the Flowers* (1943) by Jean Genet. She also loved *Therese* (1927) by François Mauriac (the complex religious questioning and Catholic philosophy appealed to her) and Dostoyevsky's dark fatalism. On this score, I was surprised to hear her saying that for some time she had thought that these authors were writing in English.

I later lent her a copy of *One Hundred Years of Solitude* (1967) by the Colombian writer Gabriel García Márquez; she read it with evident pleasure and commented: 'What a lovely foreign book!' She also gave me a quote about it for the benefit of my students: 'The English are notoriously insular; and I started to read this book with reluctance only to be won over by its combination of zany humour and sexual and political insight.' Among the modern English classics, she was very fond of J. B. Priestley and admired his play *Time and the Conways* (1937).

Beryl held a fascination for the workings of the body and its various afflictions, and was keen on medical textbooks. She enjoyed books such as *The Man Who Mistook His Wife For a Hat* (1985) by Oliver Sacks and the fantasies of Baron Corvo, who was a painter and controversial figure. But the biography of Maria Callas by Arianna Stassinopoulos won the prize for Beryl's best read: she reread our copy every time she stayed with us in Provence and was always moved by the romance and tragedy of the singer's life-story.

*

When Beryl was thrown out of Merchant Taylors' Girls' School for illustrating some lines from a naughty limerick, which she claims a friend gave to her, the family made sacrifices to afford to send her to Cone-Ripman School in Tring (now Tring Park School for the Performing Arts) in 1947. But the money didn't last long – Beryl had to return to Liverpool, and it was there that her theatrical career began. Her mother had always wanted her to be an actress, and had pushed Beryl into appearing on the *Northern Children's Hour* radio show when she was eleven. Then her father managed to get her into the Liverpool Playhouse through a business contact, and at the age of fifteen she became an assistant stage manager and 'character juvenile'. Working backstage at the theatre, she was introduced to a new world of experience and lived vicariously through other actors:

> In the Green Room I heard tales of hardship, of conversion
> to Catholicism, of sexual despair. At second hand I trod
> the pavements looking for work, was discarded by brutal
> lovers, dazzled by the ritual of the Mass. In the prop-room,

Beryl dressed as a boy mathematical genius for a play
at the Liverpool Playhouse in the late 1940s

huddled over the smoking fire, I listened to stories of escape
and heroism and immersion. I went down in submarines,
stole through frontiers disguised as a postman, limped
home across the Channel on a wing and a prayer.[14]

As a result of hearing about conversion and 'the ritual of the Mass' she did,
for a time at least, become a Catholic: soon after working at the Playhouse
she went to Scotland (as a member of the Dundee Repertory Theatre
Company) and took her opportunity to convert. 'In England,' she explains,
'in those days turning to Rome required parental consent.'[15]

As a small-part actress Beryl was given the role of Ptolemy, the
boy-king, in George Bernard Shaw's *Caesar and Cleopatra* (1898), a play that
she says she didn't like, explaining that she 'had no idea of where Egypt
was and why Caesar was wandering about in the desert'. In contrast, she
claims that Shakespeare's *Richard II* had brought her 'to the edge of tears'.[16]
Obviously Shaw's dry, ironic version of the Egyptian tragedy did not rouse
much emotion in the heart of a teenage girl.

While working at the Playhouse, Beryl fell hopelessly in love with
the stage designer. She wasn't prepared for what she called 'the peculiar
sensations provoked by love'.[17] When she tried to speak to the object of
her passion all she could hear was the thumping of her heart and the
nervous chattering of her teeth, and, despite all her efforts to hang around
backstage where he might see her, he never gave her a second glance. This
youthful, unrequited passion characterizes the naive and equally futile
love that Rose feels for Potter, the stage manager in *An Awfully Big Adventure*
(1989), who turns out to be homosexual.

Beryl's acting career continued sporadically after leaving the
Playhouse as she worked with repertory companies. She even appeared
in the television soap *Coronation Street* in 1961. There is a series of photo-
graphs from that period, taken for publicity: in one she appears against
the setting of her living room in Liverpool with an old samovar behind
her, which she brought to London and which features in her work.

*

In 1954 Beryl married Austin Davies whom, ironically, she had first met during one of her abortive attempts to engineer a romantic encounter with the stage designer at the Playhouse. (Austin was an art student at the time, trying to make some money by painting scenery in the theatre.) He had become an art teacher at the Liverpool College of Art and, assuming his professional role, he would look at her paintings and criticize them because they lacked perspective. He failed to recognize her style as fundamental to the attraction and individuality of her work, but, fortunately, he did not succeed in changing her approach to painting (nor did he manage to put off their daughter, Jojo, when she started to paint). Beryl did not suffer from negative feelings about her paintings, which grew in number and variety: she never agonized over them; she just did them without pretension, expectation or arrogance.

Beryl and Austin lived together in an old Georgian house in Huskisson Street, in Liverpool 8, on the edge of Toxteth. The street, which faces a church surrounded by a garden, is very smart now as the houses have been restored, but when Beryl revisited the area in the early 1980s (prior to the publication of *English Journey* in 1984) they were in a state of disrepair. 'I shouldn't have gone there,' she wrote. 'The balcony had toppled into the street and the pillars at the front door had collapsed.'[18]

Their first child Aaron was born in 1957, followed by Jojo a year later. When Beryl returned from hospital with baby Jojo she found evident signs of breakfast for two on the table. Unwilling to tolerate Austin's behaviour, she shouted just one word at him, 'OUT!', thus propelling herself into the role of single mother – a very brave act in those days. For years to come she boasted about this episode, feeling some contempt for women who are prepared to turn a blind eye to their husbands' indiscretions. Even though the separation must have been sad and painful, she felt for many years that she had been spared the acrimony of a relationship turned sour. Austin continued to help and support his children until 1974, when he emigrated to New Zealand to become Director of The Suter Art Gallery in Nelson. Some years later he started painting seriously again, and would time visits to his family to coincide with exhibitions in London. Philip and I have one of his paintings entitled *The Season of Stifled Sorrow*, which we bought in a London exhibition in 1980.

Beryl as an actress with her iconic samovar
in the background, early 1960s

22 Huskisson Street, Liverpool, where Beryl lived
with Austin Davies when they were married and after he left.
From the balcony she watched 'ladies of the night' go by.

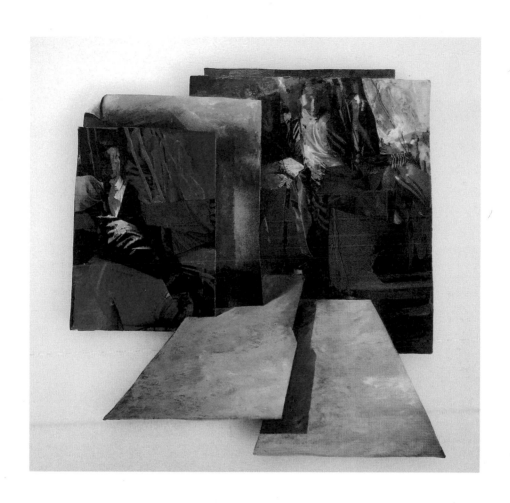

Austin Davies,
The Season of Stifled Sorrow, late 1970s

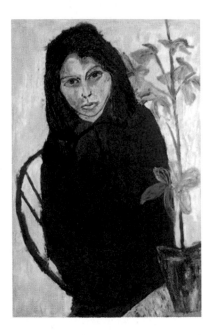

Beryl's portrait of her friend Brenda Haddon, late 1950s. Brenda
was taught by Austin Davies at Liverpool College of Art.

Despite the change in her circumstances, Beryl continued to paint
in the house on Huskisson Street. According to Brenda Haddon, she had
a tenant upstairs, which must have helped with expenses. Brenda was one
of Austin's students at the art college, who at the age of nineteen became
friends with Beryl: 'We hit it off immediately and once Aaron was born I
became the regular babysitter. Over the years we became firm friends, and
hardly a day passed without me calling at 22 Huskisson Street.' Brenda
remembers sitting at the window with Beryl, their legs hanging over the
balcony, watching 'ladies of the night' as they walked by. She also remem-
bers having her twenty-first birthday party at Beryl's home, and claims that
John Lennon (who was one of Austin's students at the time) played the
guitar for them. Later, Brenda read drafts of Beryl's first three novels. In fact
they kept in touch until the end with visits as well as phone calls. The last
time they spoke, Beryl pretended that her croaky voice was due to having
given up the 'ciggies'. Brenda says, 'She was always trying to protect me
from the nasties of life.'[19]

Beryl painted a portrait of Brenda at the age of twenty, depicting an intense, good-looking young woman in a harmony of blues: dark in the outline of the chair and the dress; pale on the potted flower. The delicately creamy background emphasizes the thick brown hair that surrounds the subject's face. 'It still hangs in my sitting-room,' continues Brenda, 'a daily reminder of our valuable friendship and her diversity of talents.' Brenda was there when Beryl's marriage to Austin broke down and offered comfort after a brief, disastrous love affair alluded to in *A Weekend with Claud*. She also fielded 'prying phone calls from Beryl's mother'.[20]

The city of Liverpool was an exciting place to be at the end of the 1950s. Young artists and poets – among them, Adrian Henri, Roger McGough, Brian Patten, Don McKinlay and Robert Evans – came together to form a lively cultural scene. As a single mother with two young children, it is not surprising that Beryl was a little detached from her peer group; but this had as much to do with her fiercely independent character as with her circumstances. Beryl first met McKinlay in Liverpool but began a long, close relationship with him after she had moved to London. In a letter sent to me after her death, he recalls, 'Beryl was never interested in the fashionable art scene, so her work was hugely individual; she became more ambitious as her ideas developed.'[21]

*

Beryl's artistic drive was not short of inspiration, and she continued painting family scenes and portraits of friends. Unfortunately, we were only able to find a few works from that period, which she took to London in 1963. To map Beryl's activities as a painter is an impossible task because she was so casual and unassuming about her work – she believed that anybody could paint. But painting was intrinsic to her family life, her writing and her fantasies. Jojo, who also became a painter, has an early memory of her mother (whom she refers to as 'Beb') at work:

> My first memory of Beb as a painter comes from the time
> when we had moved to London. I was about seven. I can see
> her surrounded by boards propped up on the living room
> floor, laying out sheets of newspaper, squeezing oil paints

Triptych painted by Beryl's eldest daughter
Jojo for her son Charlie's wedding, 2009. Jojo
was taught to paint by her mother.

onto an old-fashioned plate. I remember her telling me how
important it was to have a horizon line, and I watched as she
drew them in, varying the height from picture to picture....
It was my mother who dug out a large canvas, gave me oil
paints, a palette knife and newspapers, and told me to start
work on a self-portrait.[22]

As to the subject of Beryl's paintings: 'She was primarily interested in the
story that pictures could tell – events actual or imagined, populated by real
people, altered by her imagination,' Jojo explains. Beryl's work features
'Figures surrounded and anchored by objects – often plants or lamps,
stuffed animals in glass cases, doilies or tablecloths.'[23]

Perhaps one of the reasons Beryl did not always date her paintings is
because she was more interested in the story than herself as an artist or the
work as a piece of art. Although she liked to give the impression of being
vague about time, she never missed an appointment or arrived late at a
lecture. She must have looked in her diary almost every day; she couldn't
have functioned as a public figure otherwise.

Although Beryl liked to discuss her novels and their plots with me,
especially during the process of writing, she never talked about her paint-
ings. Jojo describes her mother's uninhibited approach:

She was a hugely original painter and painted with a surety
and freedom that remind me of her personality. She wasn't

limited by rules or constrained by the opinion or fashion
of the art world; she couldn't care less. Because of this and
because of the person she was, there is an honesty in her
work that comes from her intensely creative personality.[24]

McKinlay echoes Jojo's opinion of Beryl's individuality as a painter.
As for her technique, he describes how:

She progressed on to using scraps of hardboard primed
with gloss paint. She used materials that came to hand and
could be purchased from local shops. She had a refreshing
disregard for the technical niceties of painting, incorporating
other materials – fragments of photographs – into
increasingly complex pieces.[25]

*

By the time I got to know Beryl, she showed no particular interest in other
artists' work or visiting art galleries. As she once told the *Sunday Times*:
'I used to love going to art galleries; to the National, for instance, to see all
those beautiful huge women and gods flying about. But now I'm fed up to
the back teeth with them. I positively groan if I see one.'[26] She sometimes
spoke of the painter Frank Auerbach because he was a neighbour and she
used to see him in the supermarket or whenever she popped out to buy

some cigarettes. She attended the openings of my husband's exhibitions because he was a friend. On one occasion she even wrote a short piece for the invitation to one of his exhibitions (in July 1987), which gives a brief personal doctrine of painting: 'What one wants from art is a personal statement, a successful arrangement of colour and shape and a sense of place.' Another time, she commented on some of Philip's abstract paintings in these terms: 'I've never pretended I either like or understand abstract paintings.'[27] Otherwise she would not go out of her way to see exhibitions.

From time to time Beryl was invited as an honoured guest to dinners held for patrons and benefactors of the National Gallery. She would walk around and look at the exhibited work with evident pleasure. In 1997 the gallery bought George Stubbs's famous picture, *Whistlejacket*, and held a party to celebrate the unveiling. Colin Mackenzie, the gallery's Development Manager who had organized the whole event, personally escorted her in front of the painting. I was there with other guests who stood in awe, murmuring various comments. 'Oh,' Beryl exclaimed, 'My Little Pony!' Colin winced.

'The self-creator of her own struggling'

1963–67

Although Beryl and Austin Davies were divorced by 1959, he also moved from Liverpool to London and offered financial support and care to her and the children. Philip and I were living together and by the end of summer 1964 we were married. Beryl was writing at the time, but had not yet been published and was busy producing art because she found it easier than writing, especially as her two young children demanded attention. She painted a portrait of them sitting at a wrought-iron table, with an oil lamp and a spray of flowers, a typical setting that can be seen in several of her paintings. Brushstrokes form aureoles around the two figures: Aaron, with his dark hair and a pensive look; Jojo, with golden hair and startled, inquisitive eyes. They stand out against a background that appears to be on fire. A portrait of Aaron sitting alone shows the same oil lamp, and even as a younger child he has that intense, quiet gaze.

Beryl painted mainly on boards leaning against the kitchen table, using oils at first, then changing to poster paint and gouache in later work. Sometimes, she would find an old painting in a junk shop, which she would paint over, saying that this practice added to the richness of the final colours. As for a choice of brushes, she was not fussy and even used her fingers: she was always resourceful. She gave me a picture of Adam and Eve in the Garden of Eden, made from plasticine and decorated with edible silver balls and multicoloured 'hundreds and thousands'. I had to hang it out of reach because I discovered that my children had been picking off the decorations to eat them.

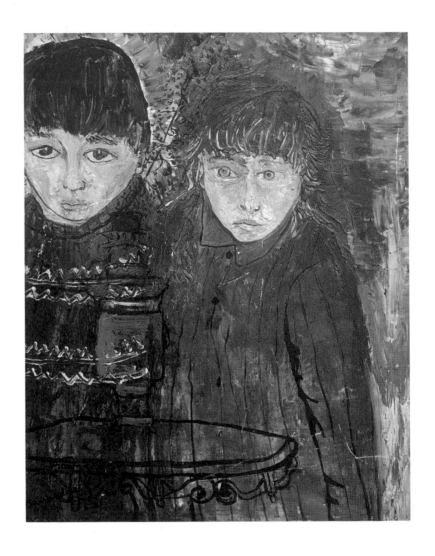

Beryl's portrait of Aaron and Jojo from the mid-1960s.
The wrought-iron lamp and table provide a familiar setting.

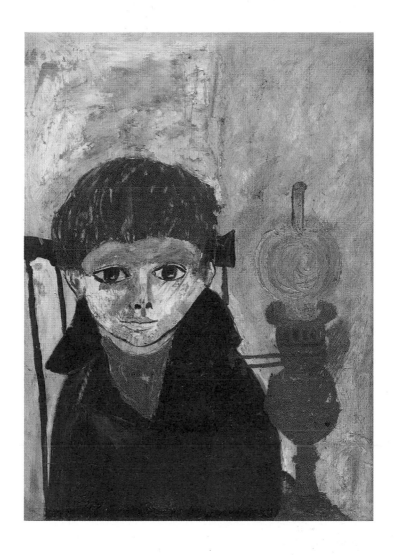

Beryl's portrait of Aaron from the early 1960s. Aaron cherishes this
portrait as intrinsic to his relationship with his mother.

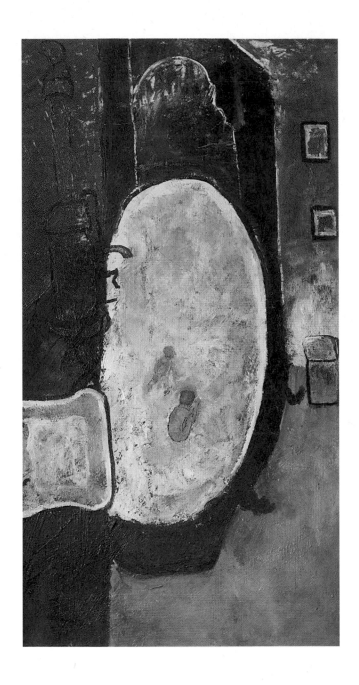

Beryl's painting of her children in the bath with a geyser, late 1950s.
The geyser features in the early novel *A Weekend with Claud*.

When Philip saw her work he was struck by its exciting combination of naivety and painterly skill, so in the winter of 1964 we organized an exhibition in our flat and invited friends for a viewing. That was when Beryl made her first London sales. Charles and Elizabeth Handy bought a painting of the two children in an old Victorian bath, which she had painted in Liverpool. Aaron remembers the bathroom with the 'old geyser that roared and whooshed as it lit', and the huge womb-shaped bath that appears to engulf the two young children in the painting. Charles Handy, who went on to make a name for himself as a management guru and became Chairman of the Royal Society of Arts in 1987, says he 'liked the colours', while his wife 'was reminded of the baths of her youth, with the old-fashioned water heater'. Elizabeth was pregnant at the time and they both appreciated the tenderness of the image, which prompted them to 'imagine their baby-to-be lying in a similar bath'. They recall that they had just moved to 'a Victorian flat with huge rooms and empty walls' and felt that the painting would 'grace them beautifully'. They paid £20, which was a considerable amount at the time but was 'still a bargain' in their view. After the sale, they drove all the way to Putney in south London with the painting strapped to the top of their car – luckily it didn't rain. Years later, they realized that 'Beryl the artist was also Beryl Bainbridge the famous author',[1] and they now have a shelf full of her books.

I bought a painting of a child sitting in a wicker chair with a toddler holding on to it, and a rather scary figure of a mannequin dominating the scene. A table and a plant are to the right of the children; a transparent curtain blows loosely; and a large red flower is in the centre, above their heads. On their left is possibly a window or another painting, a white rectangle against the dark panel behind. This is a composition of contrasting colours: the pale bodies of the naked children seem menaced by the brown figure of the mannequin behind them, who sports a fantastic hat and veil, with a fox tail slung over her shoulders. She was made by Beryl and named Emily, so Jojo tells me. Emily lived in the bathroom of Beryl's Camden home – she confronted visitors who used the toilet.

*

Adam and Eve in plasticine, 1970s,
given by Beryl to the author

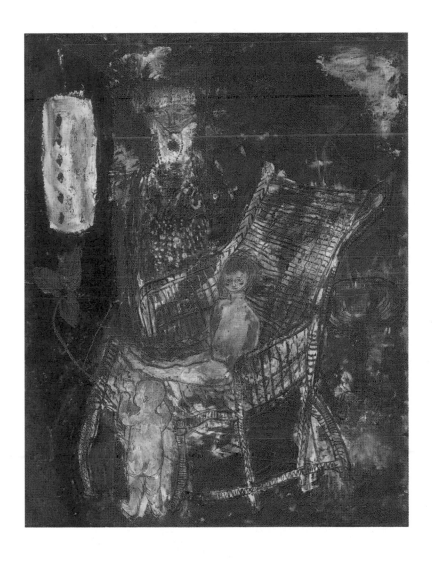

Beryl's children with a mannequin
in Arkwright Road, early 1960s

The writer Alan Sharp appeared in Beryl's life in October 1963. They first met at the Harvest Festival of the Hampstead Parochial School attended by their children. He was writing a novel, *A Green Tree in Gedde*, which was published in 1965 and won the 1967 Scottish Arts Council Award: the book was praised for having changed the face of the modern Scottish urban novel. Beryl was ready to be charmed and he fitted the bill. On one occasion, Alan took possession of a packet containing some Irish tweed that Philip had ordered, which was sitting on the table in the entrance to the house in Arkwright Road. Alan soon had it made into a jacket. When Philip recognized the material and asked where it was from, Alan answered with a smile, 'Oh I found it here and nobody seemed to want it.' Philip could only smile back.

Alan moved in with Beryl, but would move out again from time to time: he had a wife and an ex-girlfriend to care for, as well as two daughters. Beryl's drawing of *Napoleon Viewing the Field* makes me think of him. This image of Napoleon has Alan's square face, his mop of curly hair and his swaggering attitude. The smudge at Napoleon's crotch is suggestive of Alan's overt sexuality; the field that he views, and the battles for which he prepares, are not military in nature. In the background is a female figure, typical of many women in Beryl's art. Half-hidden by a chair, she looks on, wondering what Napoleon will do next.

But Alan could also be seductively romantic. Beryl described their relationship in *Sweet William* (1975):

> They both appeared pale and languid in the street.... It was only the second time she had been in the open air with him, unless she could count the moments they had leaned out of the bedroom window to watch the dawn....
>
> 'I feel so weak,' she said, 'We ought to buy some food.'...
>
> 'Loving you,' he said, 'I don't feel the need for food.' She thought how romantic it was that he was going without nourishment because of her.[2]

The following summer, Beryl enjoyed a holiday with Alan on the Greek island of Skopelos. On her return she was visibly – and gloriously – pregnant. A second daughter, Rudi, was born in March 1965 and my

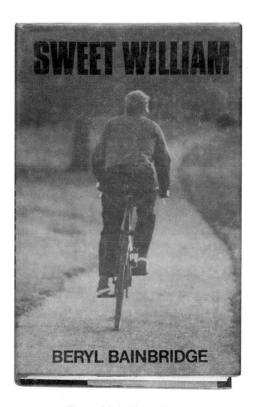

Sweet William, published by Duckworth in 1975

Le Creuset casserole was used for the baby's first bath. His task accomplished, Alan moved out as quickly as he had first moved in. The parting is recounted in *Sweet William*. Ann, the female protagonist, has just had a baby and is resting. William, the baby's father, is by the bedside, smiling. After some time William 'looked at the child, touched its frail head and excused himself. "I'll be back in a moment," he said.'[3] But of course he doesn't come back. Nor did Alan.

Beryl became very depressed. I feared for her life for the first time (although not the last, as she was prone to periods of deep depression), but in typical style she bounced back and started painting and writing again while nursing her new baby. A few years later, Rudi can be seen with her older brother and sister in a family portrait. They are sitting at the kitchen table: Aaron has his arms protectively around Rudi's shoulder,

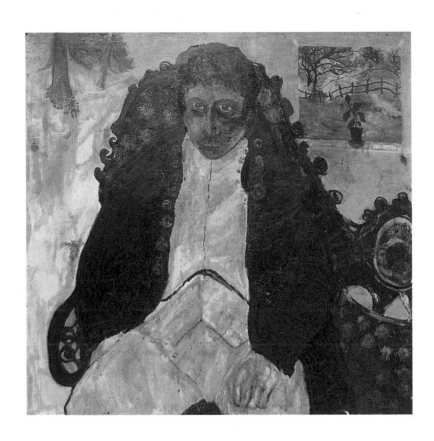

Napoleon and Friend When Young, 1969–70

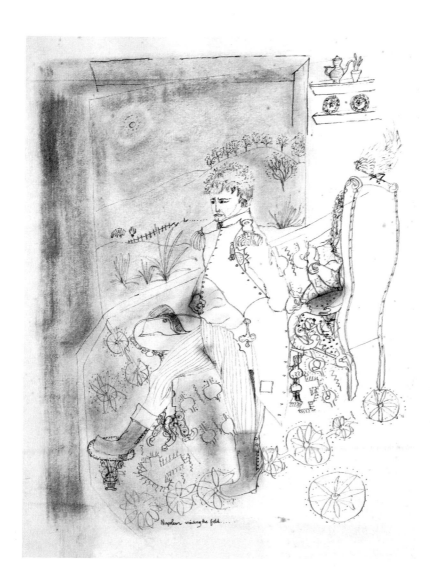

Napoleon Viewing the Field, 1969–70

while Jojo reassuringly holds her brother's hand. The three were a tight unit. For many years Rudi worshipped her elder sister and a cake could not be enjoyed unless shared – a birthday party would not begin until Jojo was present.

<p style="text-align:center">*</p>

In 1967 Beryl was able to approach Hutchinson (New Authors Limited) with the recently completed manuscript of *A Weekend with Claud*, which became her first published novel. In this book she uses the names of its three main characters – Maggie, Victorian Norman (so called because of his attire) and Shebah – as titles for the three sections that follow Claud's introductory narrative. They all speak in the first person, a method that she uses in later novels. The novel is set in Hertfordshire, where Claud runs an antique shop, and Morpeth Street (actually a Liverpool street not far from Beryl's previous home) where Maggie and Norman live in a 'one up, one down'. Shebah lives around the corner but often spends the night with her friends.

The writing is autobiographical: Beryl portrays herself in the character of Maggie and features people who crossed her path during her Liverpool years. Brenda Haddon (see page 36) is depicted as Brinny, the name Beryl used for her in real life. Brenda recognizes many of the characters in the book: Claud is based on Ronnie Harris who ran an antique shop in Tring; Victorian Norman was known in Liverpool as Harry the Lion; Shebah was Leah Davis; and Billy was a lover of Beryl's, whom she called the 'Wild Colonial Boy' in real life as well.[4]

Maggie is typical of female characters in many of the early novels, whether set in Liverpool or Camden. She is quirky, and leads a somewhat chaotic life; Beryl occasionally fitted this description, but it is not representative of her true character. In fact, she rejected her reputation as an eccentric:

> What they don't realize when they say I'm a bit eccentric
> – and it's the only time I get hot under the collar – is the
> discipline needed to get something done and get it done
> properly – and in the early days bringing up a family as well.

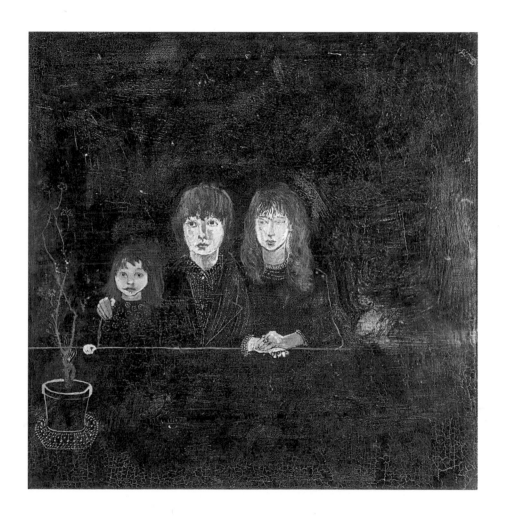

Beryl's portrait of her children, Rudi, Aaron and Jojo,
in Albert Street, 1968–69

What you do need is enormous discipline – eccentricity
doesn't count for a flipping thing.[5]

Maggie is also full of contradictions, as her friend Claud describes:

Maggie has chosen life. She is the self-creator of her
own struggling, her own griefs, her own happiness.
She endures self-loss only to fling herself triumphantly
back into an emotional battle to regain herself. She will
not, she cannot, seeing she is the only contestant, give in.
That is the glory of her.[6]

And in her physical appearance Maggie reminds us of Beryl: she is skinny, because she has no interest in food, with a hooked nose (to which she repeatedly refers). She is sometimes plain, but can also look dangerously lovely, with a 'smile of exquisite correctness on her assassin's face', as Norman says.[7]

The story of *A Weekend with Claud* opens with a photograph of the main characters, which Claud holds very dear. It shows three seated figures: Maggie sits between Joseph, the man she marries, and Billy the Wild Colonial Boy, who mysteriously exits her life even though he is in love with her (which is what happened in reality). An old woman, Shebah, stands behind the group and apart. She is Jewish but also deliberately and forcefully anti-Semitic, despite carrying the emotional burden of all the pogroms of her ancestors. Her physical separation from the group reflects her shocked fascination for their unconventional promiscuity – their idea of love is so very different from her idealized romanticism.

Claud encouraged Maggie's taste for old and sometimes exotic objects, such as the samovar (see page 31) and the stuffed eagle we see in Beryl's paintings, as well as a love of old photographs. (It was difficult to distinguish the photographs hung on Beryl's walls: there were genuine shots of relatives and ones she had bought in a street market, cheek by jowl.) Claud's shop in the novel is compared to a bazaar where 'Maggie, childlike in her delight, stood with legs well apart, puckering her nose; surprisingly, dimples appeared in the drawn face, the phosphor eyes shone emotionally'.[8]

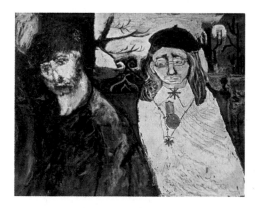

Beryl's mid-1960s portrait of *Claud and Shebah*,
two of the main characters from her novel *A Weekend with Claud*

Four paintings are closely connected with *A Weekend with Claud*, and were completed before publication. The old geyser, which dominates the painting bought by the Handys (see page 45), features in this novel in the bathroom at Morpeth Street. Here it scares the life out of Norman: 'Behind a wall of flame, Victorian Norman calls for help. In the bathroom he stands dripping in his tiny black satin underpants...sulphurous flames sear up the copper side of the antique geyser.'[9]

Then there is a double portrait, *Claud and Shebah*, which Beryl later sold to a friend and admirer, Harold Retler (see page 66). Here, Shebah is definitely recognizable as Leah, but the portrait of Claud doesn't bear any resemblance to the character described in the novel, who after the departure of his wife 'had not been aware of the gradual accumulation of flesh. It had been almost a surprise to find himself finally so large and bulky in his person.'[10]

A portrait of *Three Friends* appears in the novel as painted by Maggie. Shebah describes the painting in her narrative:

> Maggie did a painting last winter of the three of us sitting
> down on the sofa with the paraffin lamp dangling just
> above my head. Why she had to put that in I cannot imagine,
> though there may be some symbolism. It was very clever,
> the painting, because though she could not have intended
> to capture it quite so subtly, we all looked so joined together

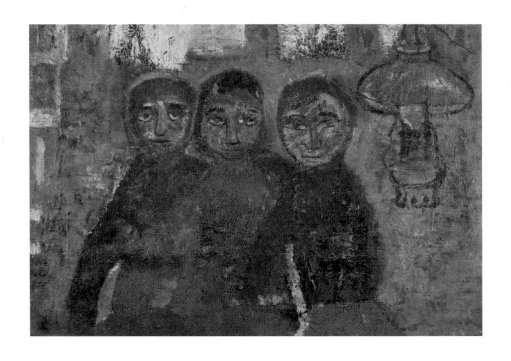

Three Friends, 1966

by blobs of paint, so chummily bunched together, and yet
on each of the three faces (though it doesn't look in the
least like me and why she had to paint those scarves round
my head I don't know) there was such a look of distaste,
such enmity in spite of the friendly grouping. And that's
how we are really.[11]

The fourth painting, a portrait of Leah Davis, which was among the
paintings Beryl brought to London from Liverpool, shows Shebah's severe
ancient face with 'a moustache and a broody lower lip'. Her 'myopic eyes
behind the double lenses' emerge from the stark white collar. But two
paintings also appear in the background. Beryl often included other works
in her pictures, as well as windows in the background. Perhaps Shebah is
right: 'there may be some symbolism'.[12]

Beryl was always attracted by the history of the Jewish race. In
A Weekend with Claud Maggie is intrigued by Shebah's appearance and
language, as well as her ancestry. She describes 'the voluptuary lower lip,
and above the mouth incredibly the nose comes forth chiselled and dis-
ciplined', and thinks of Shebah's way of speaking as 'verbal seduction.
The miasma of words begins in the eyes.' Maggie concludes: 'I wish I had
learned about Jews before I became a Catholic.'[13]

Leah Davis was not the only Jewish subject to arouse Beryl's inter-
est as a portraitist. She also painted Lili Loebl (married name, Todes),
whom she met while living in Arkwright Road. Lili was a journalist, who
had worked as a correspondent at the United Nations, and was married to
Cecil Todes (also Jewish), a child psychiatrist of South African origin. Beryl
sympathized with them and they remained friends until her death. In Lili's
words the portrait represents:

> ...a large woman with huge thighs, one leg tucked under the
> other. She is seated on a heavy, wood-carved chair, leaning
> on one side to reveal faded, plush upholstery on the back and
> the arm rests. And, under a mass of hair retained by a flower,
> she has a wistful look that was intended to portray my
> Semitic ethnicity. Behind the figure, propping up the armchair,
> stands Captain Dalhousie, and the background is covered
> with doilies, with which she said she was experimenting.[14]

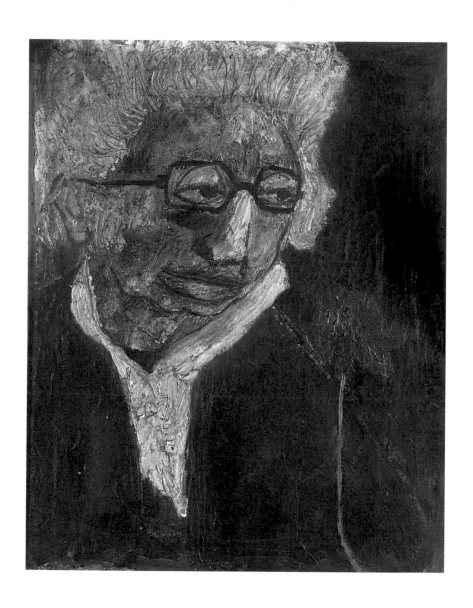

Beryl's portrait of Leah Davies, late 1950s.
Leah inspired the character of Sheba in *A Weekend with Claud*.

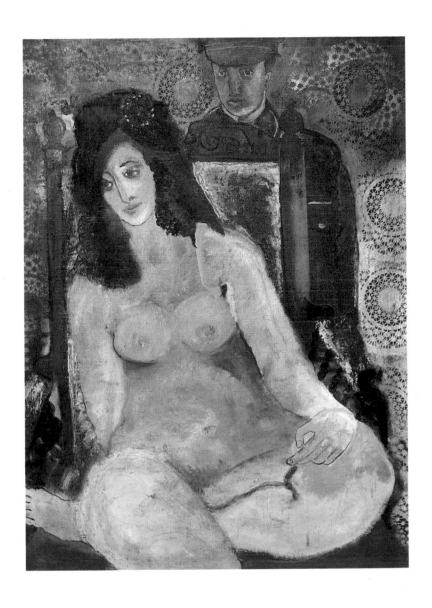

Portrait of Lili Loebl, who was Beryl's
neighbour in Arkwright Road during the mid-1960s

She was meant to be nude, but at Rudi's request Beryl added a blue veil, which Lili thinks 'accentuates rather than conceals'.

Lili bought the painting and it was proudly displayed at dinner parties attended by Beryl. To Lili's embarrassment one of the guests once asked her: 'How could you allow anyone to portray you in such a horrible way?' 'Beryl laughed, then and on many occasions afterwards,' Lili remembers.[15]

<center>*</center>

In 1967 Beryl moved her family into a terraced house in Albert Street, Camden, which Austin Davies had bought and later made over to her when he emigrated. For a while he lived in the basement and worked on renovating the house, then he moved to Islington with his new wife, Belinda. In those days there was a popular market, selling mainly fruit and vegetables, just off Camden High Street. On Fridays there was a stall selling bric-a-brac that usually attracted Beryl's attention. She liked to buy an assortment of collectables: old photographs (to hang on her kitchen walls); religious icons; and stuffed animals, which populated her rooms. She also bought old pictures, either painting over them or using their frames for her own paintings. On one occasion she bought a picture called *Man in Bowler Playing Cards*. She painted over the original image (Rudi, who owns it, says that the colours of the old canvas are visible from the back) and presented it at a selling exhibition (probably one for the Vietnam Medical Aid Campaign) for the price of £45, which is written on the back. Fortunately for us the painting did not sell. In Beryl's version, among other changes, the bowler hat has been transformed into a crop of thick black hair. But the title remained. Sadly, the stall, which was run by a man who insisted on dealing in half-crowns, shillings and pence long after the switch to decimal currency, is long gone.

Philip and I had also moved house to nearby Kentish Town, but this did not prevent Beryl and me from seeing each other every week, and we kept in touch by telephone and letter. These communications occurred mainly when we started spending time in France on holiday, with Beryl often joining us for part of our time there. Otherwise she would write and in later years she liked to send us a fax: she had to go to the post office in

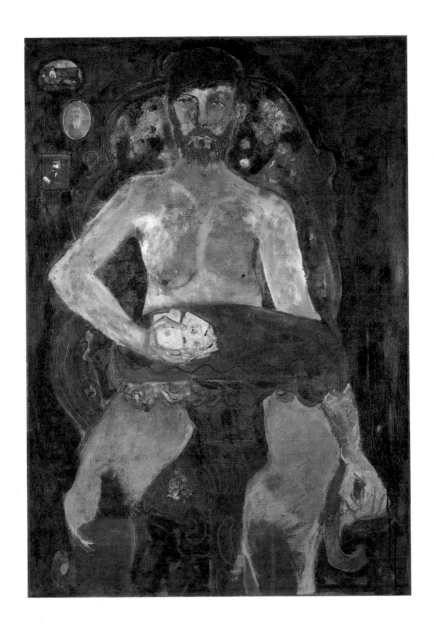

Beryl's portrait of a man playing cards,
originally titled *Man in Bowler Playing Cards*, late 1960s

Camden High Street to do so, as home fax machines were not yet widely available. She would keep us up to date about the situation back in the UK, summarizing political events and so on in her favoured witty style. She also started a tradition with the 'Ambridge Gazette', reporting on the BBC Radio 4 soap *The Archers*, a programme to which we were both addicted.

Beryl soon imprinted her personality on her new home, adding her choice of colours, old artefacts and photographs. With so much space around her she was able to work on bigger and bolder pictures, and she began to encourage her children to paint. On this topic Rudi has a lot to say. At first she was not aware of her mother as a painter: 'It must have been another nocturnal activity,' she says, referring to Beryl's habit of writing in the small hours when her children were young. Eventually Rudi reacted to the pictures in the house: 'I have to admit that I was disgusted by her paintings as a child, not just the subject matter but the prescriptive philosophy behind them.' Inevitable conflict arose when Beryl tried to teach her to paint. Rudi resented her mother's interference:

> There was a lot of smearing and smudging of her spit on the ink of my nice clean paper until it wore away, or the scraping away of a well-judged brushstroke with a rag on my board.
> There was a lot of interference, so I am prejudiced.

And she describes her mother's overweening sense of how to paint: 'For her there was definitely a right way, which I would say was very like how she felt about writing.'

Beryl gave art lessons to two of Rudi's friends. On these occasions she attempted to theorize her style, which involved 'drawing a line across the middle of the board as a sort of horizon. Paper doilies were added for texture.' And Rudi asks: 'I wonder if my friends learned anything?'[16]

Rudi also describes her embarrassment and shame at the depiction of couples in Beryl's art: 'The not so very unconscious political incorrectness of the naked women's obeisance to the fully uniformed soldiers...her certainty of the old world order.' But, she adds, 'I don't feel that now.'[17]

It wasn't just Beryl's visual representation of women that disturbed Rudi: she also considered Beryl's position on feminism to be negative. Beryl liked to be controversial, to go against contemporary thinking: she declared, 'Men are more capable than women.' But she was equally

Beryl at Camden Market, late 1960s

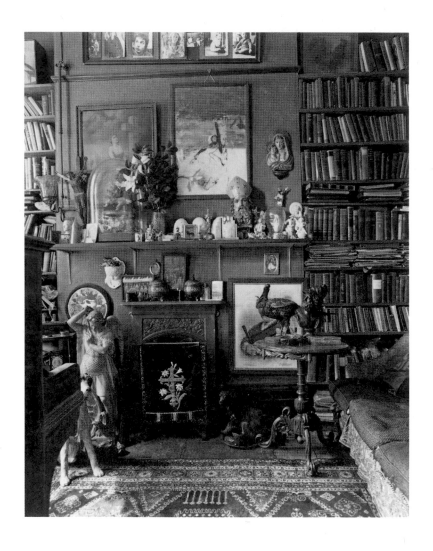

Beryl's room with books,
pictures, icons and other collectables

negative about men's sexual behaviour. In her opinion, the difference between the sexes boiled down to their contrasting feelings about love and sex. She once told me, 'Women are programmed to love completely; men are programmed to spread it around. We are fools to think any different.' One of her characters, Scurra, declares in *Every Man for Himself* (1996): 'Good Heavens! Love is what women feel.'[18] How often Beryl confirmed this sweeping statement, for she repeatedly fell in love in the most extreme way. She would sit at the end of the phone, hoping for a call from someone special. 'Ring, ring!' she would say, fixing her eyes on the receiver, willing it to comply with the full force of her emotion.

'Napoleon
in an assortment
of situations'

1967–72

Don McKinlay, whom Beryl had met as an art student in Liverpool, occasionally turned up in London to stay with her. Don had continued to paint, and some of his work was eventually to be seen on Beryl's walls. He was a vigorous, resourceful man. 'He cooked curries,' Aaron remembers. 'He had been to India on sabbatical from Manchester College of Art. He did lots of paintings there with Indian imagery and decoration.'[1] Philip and I met Don with Beryl, and it was obvious that she had fallen in love with him, although their arrangement was clearly quite casual.

In a painting from this period, Beryl portrayed Don as another Napoleon (see page 68): she seemed obsessed with the French Emperor. Why such fascination? Did she see him as a symbol of power and masculinity or one of failure in enterprise? When we visited Paris together in 1995, the first site she wanted to see was Napoleon's tomb at Les Invalides. She wrote: 'It was a marvellous 2 days. I loved the exhibition and the route marches. I am at least 2 inches shorter and my foreskins [shins] are somewhat warped, but still....'[2]

Then Beryl was distracted by an American friend of a friend who came to visit us in London and who looked after our dog while we were away. He was a computer programmer from Washington and his name was Harold Retler, although Beryl ignored his surname and referred to him as 'Washington Harold'. He was the quiet type: withdrawn, hesitant, almost timid – but he quickly fell under the spell of Beryl's magnetism. She seemed to bring out the best in him and even made a Napoleon of him – she had him singing and dancing to the strains of an old-fashioned

Don McKinlay, *Beryl at Eaves Farm*, 1969

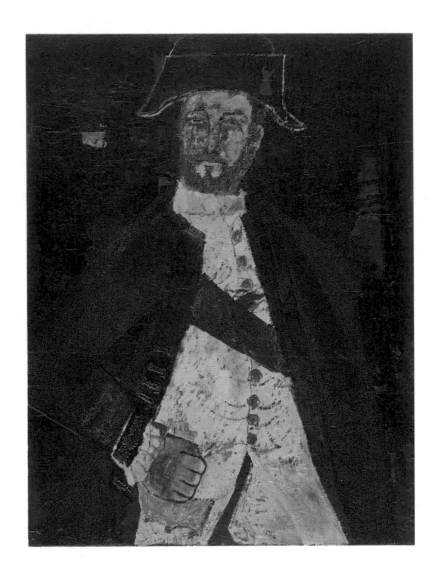

Beryl's painting of Don McKinlay
as Napoleon, mid-1960s

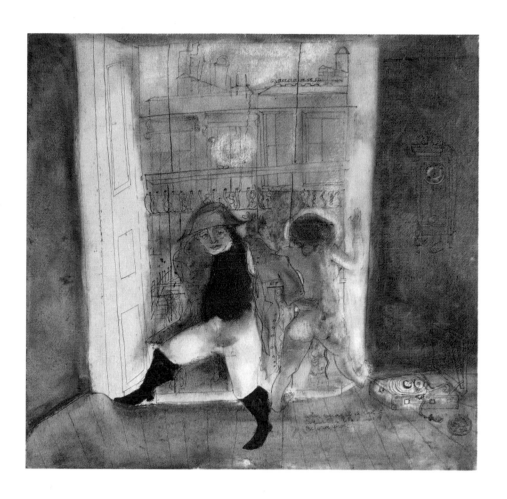

Napoleon Dancing at 42 Albert St, Camden Town,
to the Strains of the Gramophone, 1967

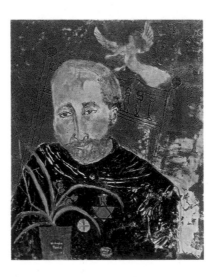

Beryl's 1967 portrait of Harold Retler, whom
she called 'Washington Harold'

song: 'There is something in your eyes, madam, I feel in paradise, madam.'
Harold writes: 'It was one of our favourites. Beryl used to play it on her old
wind-up phonograph.'[3]

As he was an American, I assumed he was rich – richer than Beryl
anyway – and I encouraged him to commission a painting from her. So
she painted his portrait. There he is, slightly balding, with a beard, and
seeming a little worried. But she decorated him with a medal and a rather
forlorn-looking plant. He has an angel hovering over his head. 'I posed in
her bedroom studio,' Harold continues, 'in the big rocking chair. The angel
was my idea, representing the American novelist Thomas Wolfe and his
first book *Look Homeward, Angel*.'[4] Beryl refused payment, so Harold bought
one of her self-portraits in pen and ink, and the double portrait, *Claud and
Shebah* (see page 55). Harold tried his hand at painting during his stay in
London. We have a picture by him of our dining room, furnished with a
Habitat table and chairs.

Beryl had a short love affair with Harold, which appeared to come
to an end when he returned to the United States. But a year later he sug-
gested that she came to visit him so they could drive a campervan across
the country. Out of curiosity and with a spirit of adventure, Beryl set off,
leaving her three children with Austin and his wife Belinda.

The adventure did not live up to Beryl's expectations – nor did Harold. Her final novel, *The Girl in the Polka-dot Dress* (2011), is based on their journey and the main protagonist, Rose, describes disappointment at her flawed travelling companion (also called Harold). Beryl kept a journal, in which she describes the tediousness of sitting for hours on end as they travelled along deserted highways, unable to stop and talk with people. She was particularly intrigued by her glimpses of families who lived on sites at the roadside: overfed mums and dads, and children playing baseball. Youngsters overtook them in crowded cars, scattering empty cans by the roadside. As a distraction, Beryl kept up with her art: propping her journal against the dashboard, she drew bushes glimpsed from the campervan windows. Perhaps she intended to turn some of these sketches into paintings because she annotates them with suggestions for the use of colour.

Beryl takes mental shots of the view from the van windows of 'water towers, which are very beautiful, on fragile stilts – great global blue and green and pink containers, rising up out of the litter of used car lots and gas stations'. She describes her first glimpse of San Francisco: 'To the far left, above and beyond the brown humps of hills wiped clear of mist, no doubt San Francisco, and unless the fog clears most like I'll never see the Golden Gate for its glitter depends on the reflection of the sun.'[5]

Self-portrait by Beryl in pen and ink, 1967

Harold Retler's painting of the author's
dining room furniture, 1968

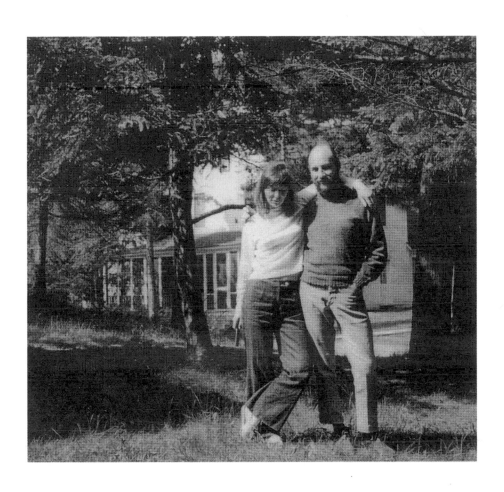

Beryl with Harold Retler at Wanakena,
St Lawrence County, New York, 1968

Pages from Beryl's journal,
written during her trip across the States, 1968

During the journey her thoughts turned to home: she worried about the children and missed them, the hustle of early mornings, getting them ready for school, cleaning shoes. She also had memories of her mother – of 'brushing soft lolling heaps of lupin petals into a doll's dustpan' as a child – and questions about her father: 'Richard Bainbridge, my long dead father without a tombstone. What did he dream his limits were? Did he truly know whom he had fathered?' But above all she thought of Don. She describes dreaming of him in 'a sudden recalling so true that it is as if nothing before that moment was real, that indeed before was a dream and now reality'. She experiences 'a terrible urgency to show him this stretch of road, this view, this glimpse of lake, clay-brown and pitting under rain… few and fragmented reasons for believing that love exists and is unique'. And later she laments: 'What is the good of seeing the world if I don't see it with you…. Ah ruddy glaciers across which I slithered, helpless in the cold.' She anticipates the happiness of the future reunion, and becomes tender and passionate: 'This is for you, Don-Don, if by any chance without booze or in extreme tiredness I cannot show or tell you my feelings when I see you.'[6]

Out of this rather negative experience Beryl found the seed of a future book, which she contemplated when sitting in the campervan: 'Theme of the new book should be a journey,' she writes, 'but in what form?' She remembered that a road journey across the States is central to the plot of *Lolita* (1955) by Vladimir Nabokov, and muses, 'Be nice to write a simple story about being in the woods 100 years ago…something called *The Idyll*…without any analysis, at least not the sort I usually indulge in,' giving an uncharacteristic example of self-consciousness. She sometimes talked about the way she wrote, including her method; she even discussed episodes in her plots; but she never in my memory referred to the psychological insight of her characters.

Beryl came to the realization that she could 'begin to think more creatively than for a long time…no distractions of the children, no housework, only the daily wandering from track to mountain and forest and beach – a sort of driftwood life'. But then she realistically admitted that her reverie was 'not entirely unpleasant when the knowledge of termination is imminent'.[7]

During the return journey she contemplated the meaning of time. When she asked Harold for his opinion on the subject, he 'went into figures and mathematics'. 'How stupid can you get?' she comments in her journal, and instead provides her own answer: 'Time is the space between seeing Don.' Then, as they crossed from the United States into Canada on 5 June 1968, one of the border guards told them that Robert Kennedy had been assassinated. Beryl recreates a desperate voice transmitted on the guards' radio as she makes a record of events in her journal: 'Oh my God, my God! They can't have.... They have shot Senator Kennedy. The assassin is standing in front of me at this moment. He is still pointing the gun.'

Years later, Beryl managed to weave this historic event into the narrative of *The Girl in the Polka-dot Dress*, giving a sensational climax to her retelling of an experience that in reality had proved so disillusioning. The political intrigue behind Robert Kennedy's death concludes her story, adding the edge of an unresolved mystery.

In 2011 Harold sent me a letter and package containing reviews of Beryl's books, articles and interviews both from the American and the English press, which had been lovingly collected over the course of time and devotedly filed. Evidently Beryl had not forgotten him either, given the theme of her last book.

*

On her return to England, Beryl resumed her relationship with Don: it was almost as if she had never left him, given the feelings expressed in her journal. He was renting a wonderful National Trust farmhouse, Eaves Farm, in the Pennines, near Holshore and Ramsbottom, and invited Beryl to stay, kids and all. Aaron remembers the farm 'with pigsty, small outbuildings, [and] bantam hens wandering into the house'. They had fresh eggs for breakfast.[8]

Beryl didn't seem to feel the need to write during this retreat. Instead she concentrated on drawing, influenced by Don's work – 'at least in terms of subject matter: he did lots of erotic stuff,' Aaron explains. 'He was quite organized there. One chair in each room had drawing material beside it, so he could sit down and draw. He got us to make models of figures from plasticine or wood.'[9]

Down at the Farm, 1969–70

Jojo and Aaron had been removed from their London schools and sent to local schools in the Pennines, which was disruptive, especially for Aaron, the oldest and most committed to his schooling. Rudi was still only three years old and not yet at school, so Beryl had to divide her time between being a mother and an artist. But the retreat had its good moments and her talent blossomed. As there was not enough money to buy paints and boards, she took to drawing: 'A large body of drawings were produced from this period,' says Jojo. 'She often used black ink, some with thin washes or daubs, often with smudges or greys.' Some of these works suggest that Beryl enjoyed a period of calm and happiness with her Napoleon, who sometimes appeared as contented, prancing, with one sock on and one off, together with his naked female companion. For a while life seemed good – full of 'rural' pleasures, as can be seen in some of her drawings. Don describes her process when she was at work:

> Her prints were small-scale works and were characterized by
> the use of a mapping pen and Indian ink in scratchy spidery
> lines touched with tone and wash.... Art was an extension of
> Beryl's writing and another aspect of her creativity that clearly
> complemented it. Living at Eaves Farm, in near isolation,
> allowed Beryl to explore the tactile pleasures of her creations
> with little to distract her. She worked at a large dining table,
> thick oak, constructed from a water tank and resting on
> some dry pillars. Through the windows we could see Long
> Meadow sloping down towards Stubbings, the Clough and
> the woods. With the table cleared in the morning Beryl could
> work during the day while the children were at school.[10]

Eventually the relationship turned sour. One drawing from this period – *There's no hope for the future...I'm off to the pub...* – shows two naked figures: a woman lies on the floor looking at a television set, which repeats the words, 'Do not adjust your set...the fault is permanent'; and a male figure stands nearby, preparing to leave. This is an elaborate scene, full of detail, including paintings on the wall, items of furniture, and curious objects on the floor such as a small animal. Beryl must have spent a lot of time working on it.

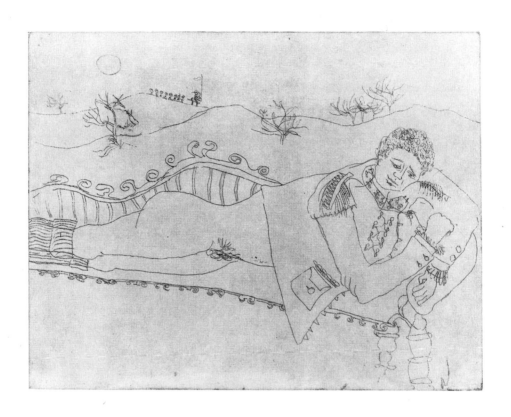

Napoleon Resting at Ramsbottom, 1969–70.
This etching is a portrait of Don McKinlay.

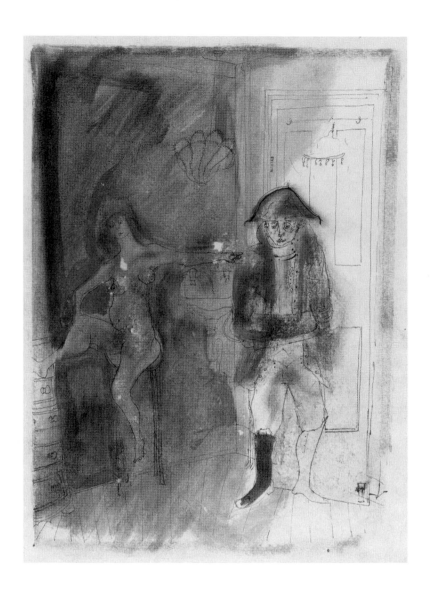

Etching of Napoleon and companion,

1969–70

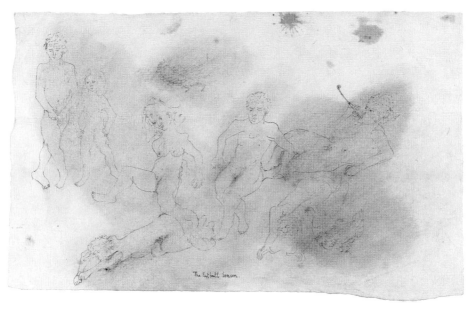

The Football Season, 1969–70

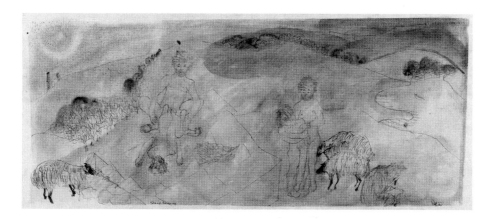

Sheep Farming, 1969–70

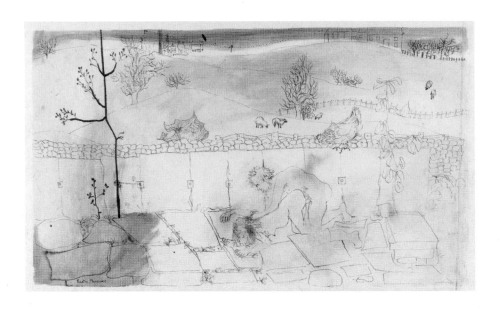

Rustic Pleasures, 1969–70

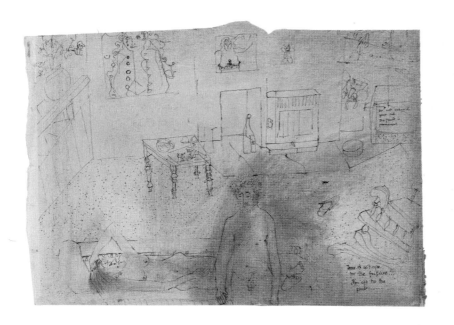

There's no hope for the future…I'm off to the pub…

1969–70

There is sarcasm in the titles of these drawings and etchings that suggests disillusion: for example, *A quiet evening at Eaves Farm or Hope does not spring eternal*. Later Beryl gave this etching to Cecil Todes and his wife Lili (Lili Loebl, see page 57). 'In it the stove in the corner is topped by her iconic brass samovar,' says Lili. 'A woman lies naked on the floor facing the television screen and Napoleon, who is opposite her in full uniform, looks at the viewer.' There's macabre detail in her work: 'In the back room, on a stone slab, [is] the naked body of a man, one foot slung over the side.'[11] In another drawing from the period (opposite), the closeness between the lovers is gone but Napoleon remains, looming behind a naked man on the sofa.

Napoleon at Harvest Time in St Helena was also gifted to Lili Todes. The title refers to the unhappy last days of the Emperor's life. Lili describes the drawing as depicting 'a naked female with exaggerated nipples and a mop of hair.... [She is] lying on her front, leaning on her elbows, and looking at the viewer. Opposite [is] a dour-looking Napoleon in full uniform, leaning on one elbow, [also] staring at the viewer. In the background, beyond a fence, is a row of martial-looking objects in a field and beyond, trees and telephone wires.'[12] In a later work, an acrylic also entitled *A quiet evening at Eaves Farm or Hope does not spring eternal*, which Beryl gave to Penny Jones (friend and neighbour), Napoleon sits at a table in the background, yet still dominates the scene with his threatening look. A naked woman is bleeding on a bed. On the floor, half-hidden by a chair, is yet another naked body.

Beryl regretfully decided to return to London. 'They burned themselves out,' Aaron says. He was sent back to London ahead of his sisters, and then the whole family returned to Albert Street. 'Don would [still] visit occasionally,' Aaron concludes, 'but I could see it was no good. Beryl was sad about it, that it was over.'[13] She bravely resumed her London life, possibly reassured that her creativity had been enriched by the experience and all she had learned from Don, who remembers 'several phone calls once she had returned to London, concerning the technicalities of printing. She had enrolled in etching classes and rang several times to ask questions and discuss techniques as she knew I had experience in the medium.'[14]

A final note on Beryl's work in the context of the Eaves Farm period: *Napoleon and Friend Retreating from Ramsbottom* shows Napoleon

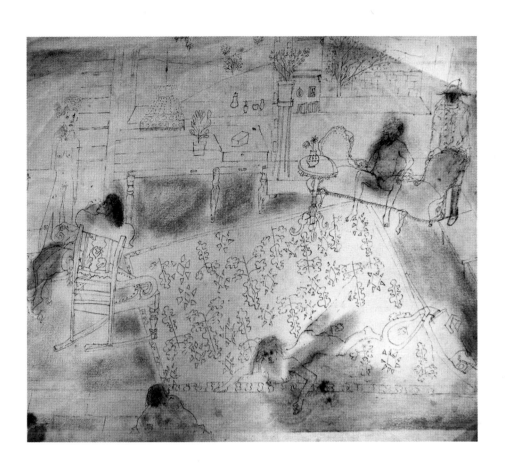

Beryl's depiction of a scene
of disillusion at Eaves Farm, 1969–70

A quiet evening at Eaves Farm
or Hope does not spring eternal, 1969–70

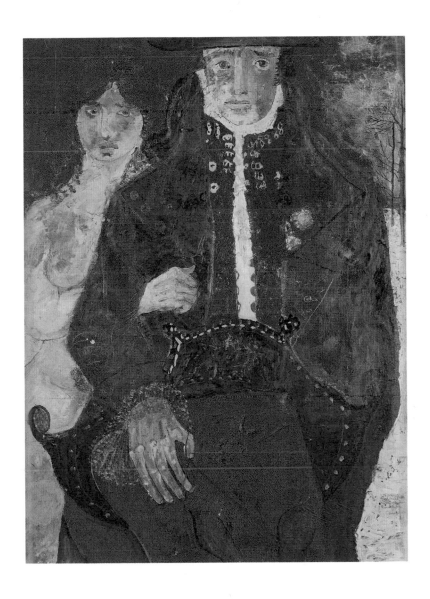

Napoleon and Friend Retreating
from Ramsbottom, 1969–70

accompanied by the iconic, soft-looking young woman who figures in many of Beryl's paintings. She appears rather puzzled by the whole adventure, while he no longer looks like the buoyant, authoritative figure of earlier images.

<p style="text-align:center">*</p>

During and after the Vietnam War in the early 1970s, several exhibitions were held in Hampstead at the Old Town Hall to raise money on behalf of the Medical Aid Committee for Vietnam. Both Beryl and my husband Philip presented some of their work. Many artists contributed, some already quite famous, such as David Hockney, Patrick Proctor, Victor Pasmore and Keith Grant. On the morning of each sale, we would cart paintings up the steps and return the following day to collect those that had not been sold.

On more than one of those occasions, we bought some of Beryl's paintings: one, a family group, celebrates the birth of my third daughter. Philip has been honoured with a medal, while my two older daughters sit on either side of the grown-ups. My first daughter looks askance at the new member of the family; while my second daughter looks on, soft and gentle. A flowerpot and decorated plates finish the scene. When we had a fourth daughter Beryl offered to add her to the original painting: she depicted her as an angel and offered to be her 'ungodly godmother'. We also bought another portrait of Don called *Napoleon on a Horse*, which she painted during one of his visits to London. It is a traditional image of the Emperor, imposing and virile, with his piercing eyes unconventionally close to the top boundary of the painting.

<p style="text-align:center">*</p>

In the summer of 1972 I introduced Beryl to Nigel and Sue Mackenzie, who ran a restaurant called The Hungry Monk in Jevington, East Sussex. As painters and collectors themselves, they were struck by the 'zany' quality of Beryl's work and invited her to show at their gallery, which they had set up with the restaurant:

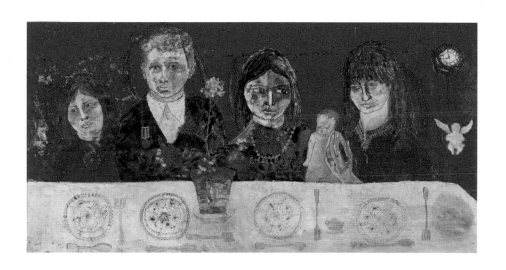

Beryl's portrait of the author's family and
the arrival of a new sibling, 1970

We met Beryl as a painter rather than a writer...she was gaining a reputation for portraying Napoleon in an assortment of situations, frequently without his trousers. Her pictures were witty, beautifully painted, in a slightly sketchy style, which gave them a freshness and contemporary feel. In many ways they were like Beryl herself – irreverent, funny and highly original – the pictures sold well: the combination of affluent restaurant customers and a private view before Sunday lunch was a pretty potent sales cocktail.... While we immensely admired her writing, we were always trying to persuade her to paint more.[15]

Philip, who was invited to exhibit at the same time, describes the event:

This was a two-person exhibition: the first one for each of us. For Beryl, it was her only dedicated one because, even though she continued and developed as a painter, her writing took over. We shared the gallery and, though there was such a difference in style and subject matter, strangely the work seemed to go well together. We can put the success down to our close friendship, perhaps.[16]

The opening ended in a picnic shared with many friends and their children. The Mackenzies bought two of Beryl's paintings, which they still own and enjoy: both show amusing scenes blending innocent nudity and a complex structure. *At Home* depicts a naked woman lying on the floor among a sea of doilies, while a naked man is slumped on a chair. Four lights, each dominating a different area of the composition, overlap, and intricate lines create a sense of connection between the relaxed naked bodies in a surprisingly urban setting. In *Photograph in Field with Chinese Pheasant after a Wizard Night Out* the characters, three male and three female, pose as a group, some seated, others standing. The men wear full, formal dress, but two of the three women are semi-naked: they all look composed and ready for the camera. A pheasant is poised before the group, wings raised, somewhat alarmed by this startling encounter in an open field. The trademark horizon line, to which Beryl's daughters refer (see page 62), is eminently visible.

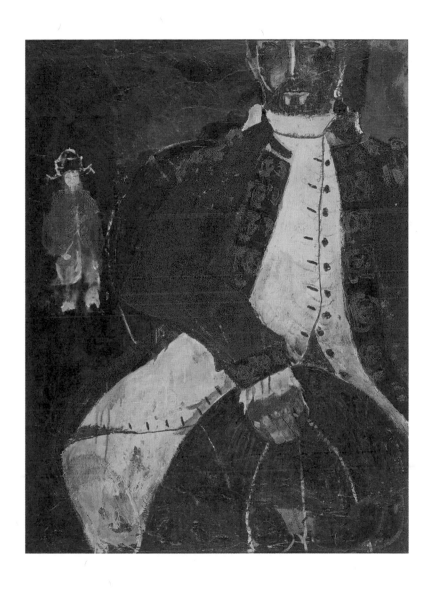

Beryl's portrait of *Napoleon on a Horse*
with a female follower in the background, late 1960s

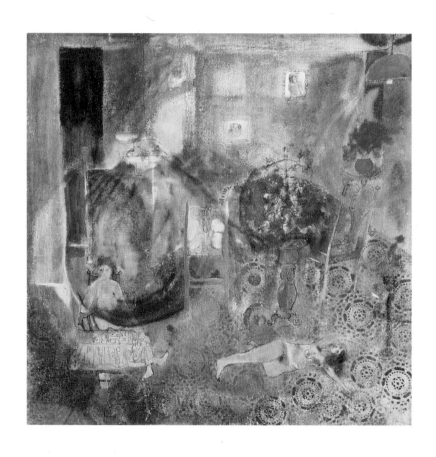

At Home, early 1970s

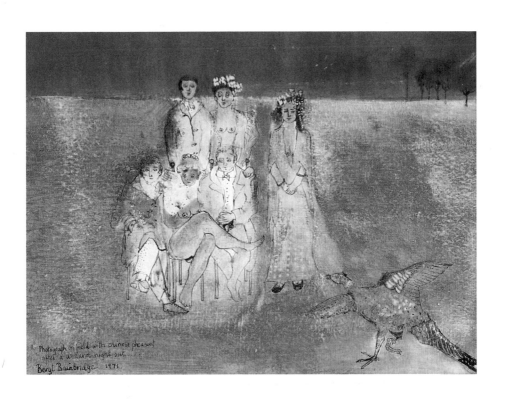

Photograph in Field with Chinese Pheasant
after a Wizard Night Out, 1971

Beryl and Rudi at a picnic
after the Jevington exhibition in 1972

Another sale of two pictures was made at this exhibition to Ted Cullinan, the award-winning architect, and his wife Roz. After Beryl's death, when every obituary talked of her novels, they wanted to honour Beryl's art and wrote a piece for the *Camden New Journal*, remembering how she began her artistic career primarily as a painter and describing her work exhibited to raise money for the Medical Aid Committee for Vietnam.[17] The Cullinans first met Beryl through Ted's uncle, Mervyn Horder, who owned the publishing company Duckworth, before he sold it to Colin Haycraft, Beryl's future publisher. She sometimes met up with Mervyn in a pub not far from the Duckworth premises. He would bring his own bag of crisps, ignoring the fact that the pub sold them. Their friendship endured and she wrote a celebratory piece for him on his eightieth birthday and held a party in his honour at her home.

The Cullinans bought *Captain Dalhousie and Friend in Motion...with a Hen*. The Captain, like Napoleon, is a recurring figure in Beryl's art. In this painting he appears with a female companion; they are both naked but for their hats, and riding a two-seater penny-farthing, a unique kind of tandem of the artist's own invention. A hen in the foreground turns her back, seemingly disinterested. The presence of the two naked legs at the edge of the painting adds an unsettling element to the scene. The Cullinans also bought *Captain Dalhousie Preparing to Mount*, in which the eponymous Captain, who has lost his hat, appears to be showing off: his body is fully stretched to reach the handlebar of his penny-farthing, while his naked companion, standing at ease, looks on from a distance.

Asked why she and her husband bought these two works, Roz told me that they were disappointed to have missed out on a portrait of Napoleon (possibly one we bought) that she had seen at the Medical Aid Committee for Vietnam exhibitions. However, they found these two paintings 'elegant and idiosyncratic'. 'They made us laugh,' she added, 'and we still smile whenever we see them. What better reason?'[18]

The existence of the Dalhousie character in Beryl's private world is a mystery. He could be based on historic figures, such as the Earls of Dalhousie, or the Captain Dalhousie who served in India during the English colonial occupation. Perhaps it was just that the name struck a note in her imagination. Compared with her depiction of Napoleon, a figure of authority who is often aggressive, Dalhousie seems a quiet,

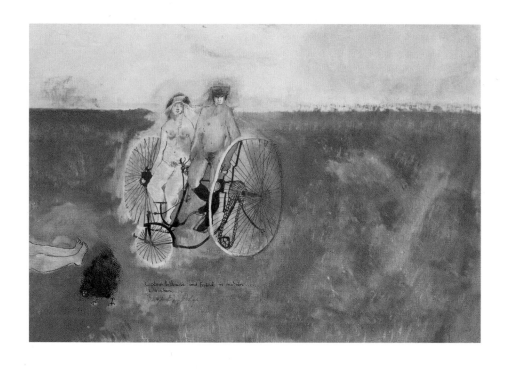

Captain Dalhousie and Friend in Motion
...with a Hen, early 1970s

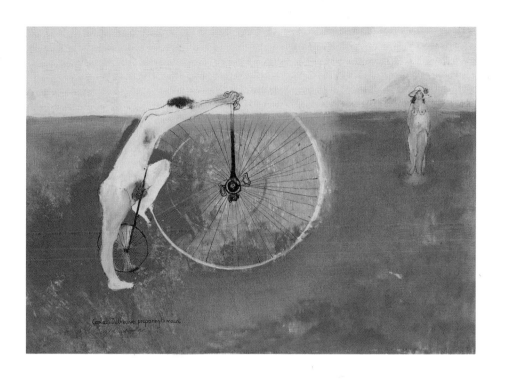

Captain Dalhousie Preparing to Mount,
early 1970s

protective and reassuring figure, as in Lili Loebl's portrait (see page 59). A decent sort of chap, even when naked.

The paintings bought by the Cullinans and Mackenzies at The Hungry Monk exhibition are part of a series of fantasies, rural idylls dreamt up in the heart of Camden. They suggest a curious episode in Beryl's creative life, as she was very much a city-loving type (possibly in reaction to her childhood in Formby); and she showed no particular interest in the countryside and fresh air. Perhaps it was enough for her to imagine it. Her interlude with Don in the remote farmhouse in the Pennines was an uncharacteristic episode, and I never knew her to spend much time outdoors. She was much more likely to view the scene through a window or, even better, through the window of her mind. Don McKinlay has suggested that these works were 'done purely for herself, remaining unseen by outsiders. There was always a strong subjectivity in Beryl's art where she combined memory, imagination and nostalgia to make it unique.'[19]

Among the art from this period in Beryl's life are similar fantasies that portray weddings: for example, *Wedding Group in Field with Hen*, and two etchings, *Night Wedding* and *Lady with a Hat on her Horse at a Wedding*. Did she hanker after the possibility of remarrying? Are these images the product of that 'nostalgia' of which Don speaks? She did occasionally express regret at her lack of a companion with whom to share the burden of running the house and solving the children's problems; but she also admitted that she had become so accustomed to her independence, and having her own way, that it would be impossible to live otherwise. In fact, after her stay at Eaves Farm with Don, she never lived with a partner. She became quite cynical about the actual ceremony of marriage: she was proud that her children were officially unmarried and boasted of having seven illegitimate grandchildren.

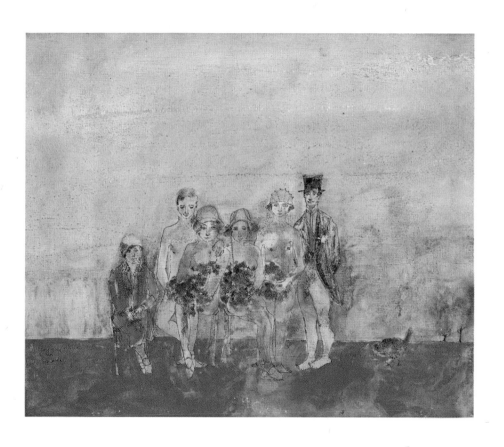

Wedding Group in Field with Hen,
early 1970s

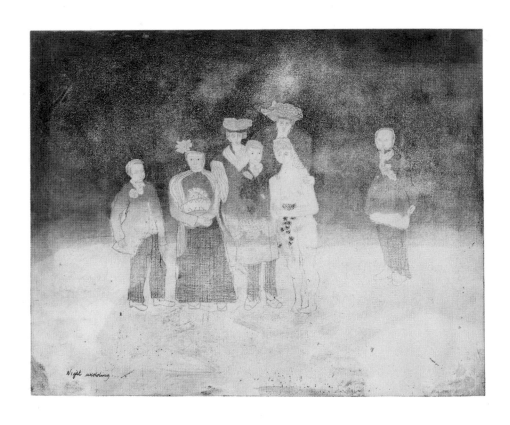

Night Wedding, early 1970s

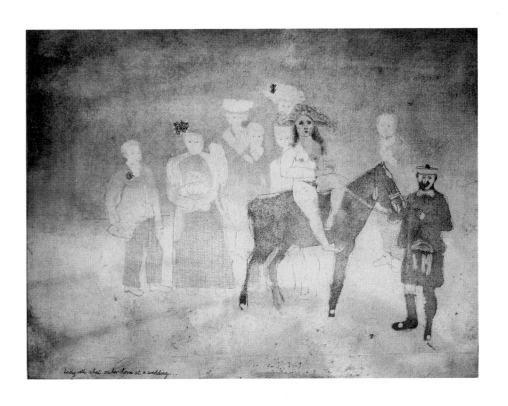

Lady with a Hat on her Horse at a Wedding,
early 1970s

'Duckworth
wanted her next book'
1972–84

The year 1972 was the point at which the balance tipped between Beryl's art and literature, and she chose to focus on her writing career. By fortuitous coincidence, she met up with an old friend from Liverpool, Anna Lindholm, after discovering that one of her sons was at the same school as Aaron. Anna was married to Colin Haycraft and worked as the fiction editor at Colin's newly acquired publishing house, Duckworth, founded by Virginia Woolf's half-brother, Gerald Duckworth, in 1898. The firm had published John Galsworthy, D. H. Lawrence and many other famous writers before the change of ownership and move to the Old Piano Factory in Camden. Friendships grew between the adults and children of both families, who were all similar ages.

Anna (who went on to write her own fiction under the pen name Alice Thomas Ellis) was always on the lookout for new talent and asked her old friend if she had written anything recently: coincidentally, the manuscript of *The Summer of the Tsar*, which Beryl had thought lost, had just been returned to her by an agent (see page 9). Duckworth accepted the manuscript, and, after revision, the book was published that year under a new title, *Harriet Said*.

Penny Jones, a neighbour, recalls the pivotal moment when Beryl was confronted with a choice between pursuing her career as an artist or focussing on fiction:

> It was autumn 1972. Beryl had two novels under her belt and
> was thinking about her third, *The Dressmaker*. Despite good

A Duckworth party with staff and some of
Colin and Anna Haycraft's children in the early 1970s.
Beryl is in the centre of the group.

reviews, there was still no definite indication of her future fame, and she had taken up painting with enthusiasm, delight and flair, inspired by her time with Don McKinlay in a farmhouse in the north of England.... I was by then well divorced, but an old friend, Terry Anne Boase, wanted to celebrate her divorce absolute, so I decided to have a dinner party for her: strictly singles only. There were ten or eleven of us including Beryl, and much wine was drunk and stories [were] told.[1]

Terry had brought Eric Lister, co-owner of the Portal Gallery, which had become a fashionable nursery for naive and eccentric figurative painters – among them Sir Peter Blake, Patrick Hughes and later Beryl Cook. Eric brought his great friend S. J. Perelman, an American writer and New York columnist who, like most comic writers, seemed lugubrious at first, but melted with time and wine. Beryl got on with both men splendidly, but clicked with Eric in particular, as he came from northern England – he was from Stockport – and shared her interest in art. At some point in the evening, all three went next door to look at her paintings. Eric was immensely enthusiastic and asked her to bring samples to the gallery the following week, which she did.

A few days later Penny had a phone call from Eric. He told her that he had offered Beryl a solo show but he had not had a definite reply – could she help? Penny went over to see Beryl, who explained that Duckworth wanted her next book, and as soon as she could manage it: this was more important. She was sorry, but her decision was made. The woman who had begun her career at Duckworth by packing books was now their glorious new author. She produced a spate of novels, published in quick succession over the next eight years: these were heydays for Beryl and also for Duckworth.

*

Harriet Said can be considered as seminal among Beryl's novels because it was her first, even though it was her third to be published. It contains the seeds of many of her later novels: the young, female narrator (who

remains unnamed throughout the book) is one of many fictional versions of Beryl – she has the author's voice and personality. And the location is recognizable: the small-town setting is clearly Formby where Beryl lived as a child at number 47, Raven Meols Lane, not far from the seashore, approached through a pinewood forest. This is the forest where she played out her romantic fantasies and adventures as a teenager: it was here that she held clandestine meetings with a German POW, as described in *A Quiet Life*. She also met with a friend of hers in the forest, and they developed a shared fantasy about a middle-aged man whom they called the 'Tsar'. Then she found an old newspaper article covering the 1954 trial in New Zealand of two teenagers, Juliet Hulme and Pauline Parker, who plotted and killed Pauline's mother. (This murder story was eventually made into the 1994 film *Heavenly Creatures*.) Beryl combined that tragic episode with memories of her early youth to write the novel, which was originally rejected

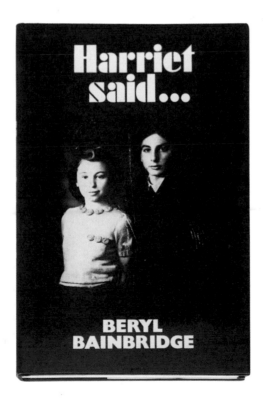

Harriet Said, published by Duckworth in 1972

by several publishers (see page 7). Brenda Haddon tells me that Beryl often found inspiration for her novels in newspaper articles, and Rudi has confirmed this anecdote with one of her own: when she sought encouragement to write, her mother suggested she took the first and last line of an article and 'put yourself into it'.[2]

As a study of teenage sexual awakening and the delicate balance on which moral behaviour depends, *Harriet Said* is a masterpiece and as such is disconcerting. The narrator is a thirteen-year-old girl, who is under the spell of her friend, Harriet. As it is the summer holidays, there is very little to do to exercise the girls' intellectual and emotional energy and channel their awakening sexuality. The narrator has had a taste of romance in the previous summer when she met an Italian POW who addressed her as a 'dirty little angel'. But one year older, her developed sexuality needs 'a more complicated tracery of sensations'.[3] She wants to be in love, to be kissed and look 'ethereal' – she is conscious of being plump, as Beryl was at that age. The narrator feels that fantasizing about the Tsar, as the girls had done until now, was childish fun, but not equivalent to the real-life experience of romance.

In the novel the Tsar is a married man. He is ageing, his hair is thinning, his pale complexion has an unhealthy yellow hue and he feels the 'injustice of old age'. But the narrator, although not blind to his poor physical appearance, believes she loves him: she needs to love him; she suffers from an excess of love – love for her friend, Harriet, as well as for the Tsar.

Both girls are aware of their loss of innocence: 'I don't know if we were ever innocent,' wonders the narrator. And later she realizes that she and Harriet had long ago 'forgotten how to tell the truth'.[4] They keep a shared diary, which Harriet dictates and the narrator writes. They never mention names; everyone has a pseudonym. Harriet is simply referred to as 'she'. The dictation takes place in Harriet's room: 'Put, "I have been here alone," Harriet's voice was muffled against the carpet. "And that you have become more intimate with the Tsar."'[5]

Of the two girls, it is evident that Harriet makes the decisions. Once the Tsar has kissed and had sex with the narrator, it is Harriet who decides: 'We must work quickly to punish him, in a way he will not like.'[6] And thus Harriet aims to strike at his domestic comfort and ruin his marriage. During his wife's absence, the Tsar invites the girls to his house. When

his wife returns unexpectedly, Harriet pushes a stick into the narrator's hand and instructs her to hit the wife, who falls and drifts 'into the darkness like some great leaf'.[7] Harriet takes control: she ensures that there are no witnesses to the crime and removes evidence of fingerprints. The girls leave and return to their houses, screaming, and the Tsar is left to take the blame.

<p style="text-align:center">*</p>

Beryl enjoyed living in Camden Town, more so than Hampstead. Not only did she have a house (rather than a flat), with the Friday market and the high-street shops nearby, but she also lived in the middle of a close-knit neighbourhood – even if, on some occasions, she had to hide behind the curtains when people knocked too often at her door. She was now unattached and fancy-free, but she was still prone to unfortunate romances: her latest was with Graham, a very young man with masses of blond frizzy hair who worked in a factory in the area. We were accustomed to seeing her with artistic, intellectual men as lovers: Graham was too young, too naive, but also too nice. She teased him and even bullied him, yet he was not deterred. When she reminded him of her age, he would sweetly answer: 'When you are too old to walk I shall just push you in a wheel chair.' He was very sad when she finally dismissed him and tried in vain to win back her favour. Beryl's friends felt very sorry for him.

At the end of Albert Street, on the corner with Parkway, there was a bottle factory where wine was bottled for dispatch. Italians owned the business and sometimes employed locals as casual labourers to wash the bottles. For a short time, Beryl worked there together with her neighbour, Pauline Mani, also a single mother of a boy more or less the same age as Rudi. Pauline was a big, blousy woman who features as the 'majestic' and 'opulent' character of Freda in Beryl's novel *The Bottle Factory Outing* (1974). Beryl didn't paint her portrait, but many people who knew her recognize her as a model for fleshy naked females who often appear in Beryl's paintings, such as the bride in *Oh Happy Wedding Morn*.

In the novel, Freda lives with Brenda (another depiction of Beryl), who has separated from her husband. The two women share a double bed, in the middle of which Brenda has placed a bolster and 'a row of books

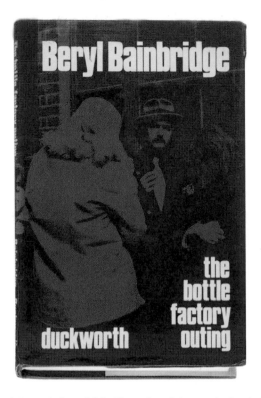

The Bottle Factory Outing, published by Duckworth in 1974. The female figure photographed here is Pauline Mani, represented as Freda in the novel.

to ensure that they lay less intimately at night',[8] and they both work in a bottle factory run by Italians. Freda is full of romantic dreams for the future. An Italian girl, Maria, has 'read' the leaves at the bottom of her tea cup and predicts 'a tall man' and 'a journey by land and sea', as well as 'a long flowing dress with flowers at the waist'.[9]

The factory owner agrees to an outing to Windsor Park for both employers and employees. When they arrive at the park, something almost magical happens: men in uniforms ride past on black horses (they are training the Queen's funeral horses). They invite the day-trippers to have a ride. Freda is 'hauled by two soldiers on to the large gelding, the plump curves of her purple calves echoing the rounded swell of the horses'.[10]

Everybody is in a jolly mood; much wine is drunk and a certain amount of flirtation enjoyed. But Freda has an argument with Brenda and then disappears into the bushes. Brenda decides to look for her friend,

The Bottle Factory Outing back cover. Beryl's publisher,
Colin Haycraft (right), poses as an Italian character from the story.

thinking that she must have gone to sleep among the rhododendrons;
instead, she finds a corpse:

> Freda looked disgruntled, her mouth sucked inwards.
> The blue eyes stared fixedly at the sky. Under the dark leaves
> her skin assumed a greenish tinge, the cheeks brindled with
> crimson and spotted with raindrops. For a moment Brenda
> thought she was weeping.[11]

If Beryl's paintings tell a story, it is also true that her writing conveys paint-
erly images.

The plot hinges on ambiguity and the possibility that Freda has
been murdered. The rest of the group panics – what should they do with
the corpse? The Italians reject Brenda's suggestion to call the police; they
decide to move the corpse and drive back to London: 'Freda sat like a large

bedraggled doll, chin sunk on to her chest.'[12] They dispose of the body by packing it into an empty sherry barrel, which will be thrown into the sea. Maria dresses Freda's corpse in a long white gown and gives her flowers, making do with the plastic roses that come free in washing powder packets; and so the reading of the tea leaves comes true.

Pauline died in sad and depressing circumstances in the hot summer of 2003. Beryl went to her funeral with Rudi, and then wrote to us: 'I can't get it out of my mind – that large bold woman who sailed up and down Albert Street.... Poor Pauline, they didn't even get her name right.'[13] Added to that indignity, 'a Camden councillor...went on about Pauline being in a novel by a celebrity writer' at the funeral. Beryl was deeply saddened by Pauline's death. The long fax (longer than usual) in which she told us about the funeral ends with these words:

> I thought you'd like to hear all this, which has a lot in
> common with my state of mind. I have written not a word
> of my new novel, painted a picture or written a review.
> I have gone into a decline.... All I want to do is crouch in
> a dark corner with the electric fan for company.[14]

Beryl was once attacked by Austin's mother, who had a gun. *The Bottle Factory Outing* fictionalizes this real-life episode: the drama takes place in the house where the two girls live together. Brenda's mother-in-law arrives to avenge her thwarted son and claim back his photographs. Freda hears her friend screaming 'Don't – Why?' and sees the neatly dressed old lady take a gun from her bag, which she aims at Brenda. At that moment 'there was a small plopping sound as Mrs Haddon squeezed the trigger'.[15] Fortunately, the gun was only an air pistol.

Beryl's painting *Did you think I would leave you dying when there is room on my horse for two?* depicts the same event in Beryl's life. She was always so slim, yet most of the females she paints, including a version of herself in this painting, are naked and fleshy. The scene is crowded with two windows, each presenting a distinctive view, and a painting of Napoleon. I recognize the painting within the painting as *Napoleon on a Horse* (a portrait of Don McKinlay, see page 91). The naked man coming down the stairs is also Don, although Beryl once told a journalist that he was a labourer doing some work in her house. Naked! Sometimes describing Beryl's life

Oh Happy Wedding Morn, early 1970s

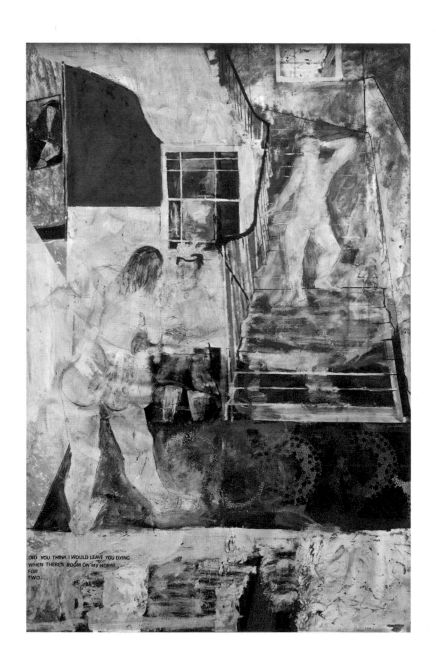

Did you think I would leave you dying
when there is room on my horse for two?, early 1970s

is like moving on shifting sands. The portrait of the mother-in-law, with her feathery hat and necklace, gives a surprising impression of someone very smart and cool, despite the flashing explosion of the gun. The rich texture of this picture, which has been painted on top of another artist's work, creates a sense of disruption and chaos.

The painting was hanging in Beryl's house long before she published *The Bottle Factory Outing*, but I can't honestly be sure of the sequence of events. Did she paint it with the book in mind? Years later she used to paint subjects related to a novel after its completion, as if to exorcize the memory of the effort she had spent in the writing. Perhaps in this case the illustration came before the narrative and she returned to the rather sensational episode to create a piece of high comedy in *The Bottle Factory Outing*. Beryl was very funny, especially so at parties or when playing with her grandchildren. In her fiction the comic is often understated, but with this novel she comes much closer to writing farce. Along with *Injury Time* (1977) and parts of *Harriet Said*, *The Bottle Factory Outing* is considered by A. N. Wilson to be one of her 'great works'. In a review of the play *Don't Dress for Dinner* by Marc Camoletti, Beryl advanced the theory that, apart from Shakespeare and Priestley, 'farce is the bestest, cleverest, subtlest form of theatre'. Would she apply this accolade to comic narrative fiction also?

On a final note: the painting title comes from a 1902 song called 'Two Little Boys', made popular by Rolf Harris in 1969. We were asked to sing this song around Beryl's open grave as part of her funeral arrangements. And so we did.

✳

Although Beryl was happily settled in Camden and had already published a novel based on her life there, she often returned to her early years in Liverpool and to her family for inspiration. In 1976 she published *A Quiet Life*, full of autobiographical references to her youth: not just the location, which was identifiable as Formby (similar to the setting of *Harriet Said*); but also the tempestuous domestic environment to which she referred when she recalled writing *Filthy Lucre* as a teenager (see page 20).

A Quiet Life is not quiet at all, with father and mother at loggerheads in a relationship based on spite and contempt: in this context 'silence is

A Quiet Life,
published by Duckworth in 1976

more brutal than words'.[16] The main characters, siblings Alan and Madge, suffer from the endless hostility between their parents, who become violent at times, willing the destruction of domestic items dear to each other: her grandfather's armchair; his beloved radio. When the family decides to take a walk to the seashore, and parental conflict seems distant, mother exclaims, 'How beautiful!', while father only notices World War Two wreckage. The domestic tension is relieved only occasionally when father promises his wife a piece of jewellery and is allowed to 'loofah her back'[17] (see page 20). Towards the end of the novel, in a frenzy of destruction, father attempts to chop down the sycamore tree and brings on a fatal heart attack.

Even in the novel's quietest moments, when life at home seems to improve, husband and wife still appear to be 'poles apart'. There is a drawing with this very title which, although not necessarily related to this

Poles Apart, late 1980s

novel, illustrates the alienation that can destroy a couple, something that Beryl witnessed while growing up and occasionally experienced in her own relationships.

The children in A Quiet Life have learnt, in their different ways, to survive in this dysfunctional family where mother spends her evenings in the train station waiting room, just to escape her husband. They turn up the radio volume to prevent the neighbours from hearing their parents argue (just as Beryl did whenever she returned home from school, see page 11); and resort to each sleeping with one of their parents, who can no longer bear to share a bed. Yet it can't always have been like this, thinks Alan, or we wouldn't be here. His sister copes through escape: she falls in love with a German POW, and her secret meetings with him at the end of each day become the focus of her life. Alan, on the other hand, seems alone with the burden of the family's emotional fallout.

Beryl didn't speak much to me about her brother, Ian, who died of a stroke at a relatively young age, except to say that he was a lawyer and married with children. In an interview with Lynn Barber, she mentioned that he came very close to having a nervous breakdown when young. In the novel Madge tells Alan that the teachers at school had warned their parents that he was 'very nervy', and adds: 'They have got you on their conscience.'[18] Although Madge has many of Beryl's characteristics (including her constant cough), the main voice in the narrative is that of Alan. He is the hero – or the anti-hero, as the narrative reveals – trying to hold the family together: acting as a go-between for his parents; defending now one, now the other, scared to leave them together alone; taking responsibility for his young sister as well as the character of his spinster aunt, Nora. In fact, Alan is like Antigone, of classical Greek tradition, left to lead her blinded father Oedipus into exile and to defy the king's edict in order to give her brother a religious burial.

Alan tries to fall in love too, but the girl he fancies is tight-laced – she will not even loosen the belt of her heavy winter coat – and she is finally repulsed when she discovers the secrets of his family life. Ultimately, Alan envies those very features of his sister's personality that he criticizes: 'No one else he knew behaved like she did or had such freedom of action.'[19] He is disturbed by her ability to get to the truth of people's behaviour, as if 'she peeled back the layers'.[20]

Mum and Mr Armitage, published by Duckworth in 1985.
The cover image shows Beryl's mother, Winnie, in pearls and fur.

The narrative opens and ends twenty-two years after the episodes central to the plot, which culminates in the death of the father. In her fiction Beryl more than once refers to the father figure in the dynamics of the family as dispensable, if not altogether undesirable. As for the mother in *A Quiet Life*, one can easily identify her, coquettishly arranging her silver fox and veiled hats, with 'Mum' in *Mum and Mr Armitage* (1985) and ultimately with Winnie. The narrative closes with the death of the mother: brother and sister meet again after the funeral, which Madge hasn't bothered to attend, in order to sort out their old home. Alan, who is now a respectable, middle-class man with a wife and children, is shocked by his sister's appearance: 'She's forty and she's wearing a school raincoat',[21] and silently judges her: 'She didn't rearrange her face the way Joan had managed to do over the years, the way he had.'[22] Madge wants to go over the past but he answers 'helplessly' that it was so long ago; he is not like her who 'had always been a great one for discussing emotions'.[23] Madge

doesn't want her share of their parents' belongings, certainly not her mother's engagement ring; she will only take the plaster statuette of a dancing lady. So Alan is left clutching the flowers Madge had brought him, which he throws away as he returns to his house, 'spick and span, freshly painted every five years'.[24]

*

In 1977 Beryl published *Injury Time*, another autobiographical book. The protagonist, Binny, decides she will do her best to organize a dinner party – Beryl was always ready to admit her lack of interest in cooking and complete disregard for food, except for the occasional plate of fish and chips or fatty bacon. Edward, Binny's boyfriend (or 'gentleman caller', to use one of Beryl's favourite catchphrases) is coming and bringing a colleague, Simpson, and his wife. But the house is suddenly invaded by a group of small-time criminals, hiding from the police after committing a burglary; they take the hostess and guests as hostages. Eventually the police arrive, along with the press. The whole story is a jest, mainly lampooning Binny's lover, Edward, a respectable city lawyer and married man who is terrified that his picture and details might appear in the papers. The comedy hinges on his personal conflict: he is aware of what he ought to do for the sake of his position, but Binny has a hold on him:

> He must break with Binny – the strain was becoming too
> much for him. He had enough to do as it was answering
> phone calls, coping with clients, studying the latest changes
> in the tax laws. After a tiring day in the office and a visit to
> Binny in the evening, it was a miracle he didn't drop dead
> from sheer exhaustion. Sometimes when he returned home,
> dark rings under the eyes and clothing sprinkled with cat
> hairs, his wife – allowing her cheeks to be brushed by his lips
> – would suggest that he was doing too much.[25]

Beryl was writing from experience: she had just such a relationship with her solicitor, who was also a director at Duckworth. As well as feeling sexually attracted to him, she resented his wife whom he described as such a wonderful hostess. She also mocked his inability to openly admit that he

Injury Time, published by Duckworth in 1977

had a mistress. Both this novel and the one that followed helped her to release these conflicting emotions and avenge her womanly dignity.

The ambience of Binny's house is akin to that of 42 Albert Street, where Beryl lived until her death and which has been frequently described and photographed by journalists who revelled at proof of her eccentricity. Muriel, one of the guests, ventures into a room upstairs:

> It was simply unbelievable. She scrutinized the pictures on the walls. There were various photographs of the same three children from infancy to adolescence. The chubby toddlers smiled, the lean teenagers scowled. There was a wedding portrait of a young Binny in a three-quarter-length dress and a small round hat rimmed with flowers. She was linking arms

with a bearded man…. He didn't look like a person who could ever have business commitments. Next to the happy couple hung two framed pictures, cut from magazines, of different men lying in black pools of blood, dying of assassination. There were a lot of books on shelves grey with dust.[26]

Beryl always kept her wedding photograph in the dining room, showing her younger self and Austin, the 'bearded man' with no 'business commitments'. Muriel's comment is one of Beryl's private jokes at the expense of her ex-husband.

*

A similar situation gains a darker undertone in *Winter Garden* (1980), which is partly based on Beryl's personal experience when she was invited as part of a group of writers, including Melvyn Bragg, Germaine Greer and Bernice Rubens, to visit the Soviet Union on a cultural exchange in 1979. Elated and amused, she told stories on her return of lost luggage, pyjamas borrowed from the Russian poet Yevtushenko, and of a night at the opera to see *Faustus*, as well as visits to farms and artists' studios.

In the novel, Douglas Ashburner waves goodbye to his sleepy wife, supposedly to take a restful holiday in the Highlands; he actually meets his secret girlfriend, Nina St Clair, a sculptress. He is joining her on a trip to Russia as her official companion, guest of the Soviet Artists' Union. The scene is bleak and wintry throughout: blackness dominates from the very first paragraph when he buttons up his black coat and thinks of 'the blackness to come'.[27] Once in Russia he manoeuvres in an atmosphere of mystery and suspense – there is a case of confused identity, lost luggage, mystifying phone calls in the night, Nina's disappearance – and overcomes danger in collisions and animal attacks. Finally, he winds up in a Soviet prison feeling like 'the victim of a monstrous conspiracy'. He now believes that he understands 'the completed picture quite clearly' – much more so than the reader.[28]

The novel's title can be read as a metaphor for Soviet Russia, but it is also the name that Ashburner's wife 'gave to the sunken yard behind the house, a paved area devoid of earth and so called because even in the

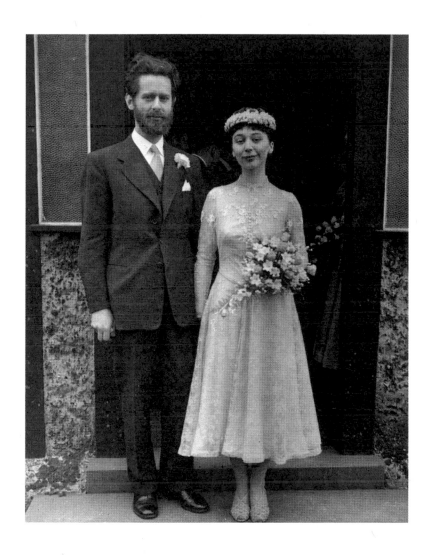

Wedding portrait
of Austin Davies and Beryl, 1954

Winter Garden published by Duckworth in 1980

summer it lay as dark as the grave',[29] a description that sheds light on the ironic intent of the whole narrative. In spite of the apparent bleakness, humour underlies the novel's various episodes, as it did in the stories Beryl told about her own Russian adventure.

<p style="text-align:center">*</p>

'The Man Who Blew Away' (a short story later published in the collection *Mum and Mr Armitage*) is in the same vein. The main protagonist is called Pinkerton – a name lifted from Puccini's opera *Madam Butterfly*, which Beryl refers to more than once in her writings. He joins his girlfriend Agnes on a holiday in Corfu, having told his wife that he is going fishing in Scotland. He is obliged to remain in the hotel bedroom to avoid the sun while Agnes returns from the beach each day looking more and more tanned. He feels

alienated: 'Her body was so dark after a week in the sun that it was like making advances to a stranger.'[30] All sorts of strange encounters take place: a kind of spooky mysticism pervades, but all in a half-mocking tone. Before leaving Corfu and Agnes, Pinkerton decides he must have 'one of those parachute rides' in which the parachutists take off from the water, behind a speedboat. At first, still tethered to the boat, Pinkerton feels cheated, until 'The sudden and furious gust of wind that seized the rope in its giant fist and tore it, steel hook and all from the funnel of the boat, was spent in an instant. Then Pinkerton, free as a bird, soared into the blue under the red umbrella of his parachute.'[31] And so the story ends.

Beryl wrote to us once, telling us that she had seen lots of 'those flying things in the sky', and she was thinking of writing a story about an old lover of hers taking one of those parachutes and flying all the way to Albania.[32] And in one of her regular 'Ambridge Gazette' reports (about *The Archers*), sent to us while we holidayed in France, she wrote that a sub-plot involving a clandestine lovers' holiday reminded her 'of going to Corfu with X who had told his wife that he had gone fishing'.[33]

On 27 September 2009 Beryl chose to read this story at the Small Wonders Festival in Charleston, East Sussex. It was a brilliant occasion: Beryl gave a great performance and had the audience in stitches. The ticketed title for the event was 'Mistress of Misrule', and her name, Beryl Bainbridge, appeared directly underneath: how appropriate.

*

Beryl published seven novels in seven years: her feverish creativity seemed unstoppable. The last of these, in 1978, was *Young Adolf*. She was obsessed with the Nazi persecution of the Jews, and images of the Holocaust and concentration camps, so it is not surprising that she should have turned her attention to the figure of Hitler in his youth. In her kitchen she had a photograph of him delivering a speech in full Nazi uniform, upon which she used to note down people's phone numbers. She also drew his image in ink descending the stairs (presumably of the Reichstag) with a large swastika above his head. Even the full-sized and fully dressed male dummy that she had sitting at her table in the living room sported a version of Hitler's moustache. On many occasions I entered the room

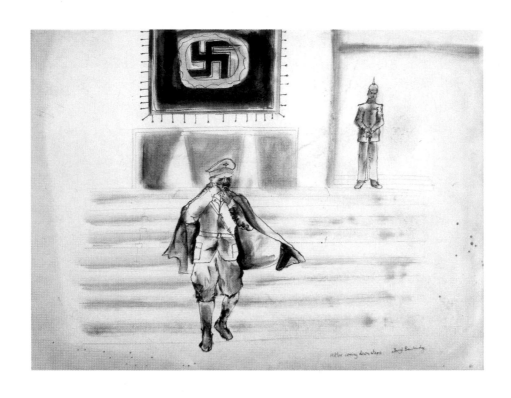

Beryl's image of Hitler,

late 1970s

(which also contained her bed) and for a second mistakenly thought that she had company.

Beryl was intrigued by the conjecture that Hitler had once lived and worked in her home town as an innocent, withdrawn young man. She made enquiries and researched from a book by John Toland (*Adolf Hitler: The Definitive Biography*, 1976), which claimed that Adolf dodged conscription in 1912 and stayed in England at the invitation of his half-brother, Alois. Hitler worked in Alois's restaurant and lived with his family – including their infant son Patrick.

Young Adolf delivers dark episodes with amusing details. Beryl seems to be winking at the reader in complicity, making allusions to: Adolf's strange walk ('arms held stiffly to his sides...shoe pointing at the linoleum'[34]); the brown material of the shirt made for him by his sister-in-law; the way she parts his hair and combs 'a section of it downwards'[35]; a fit of epilepsy; and feelings of persecution from authority (with reason, for he had an irregular passport). On Christmas Day, after dinner and a few drinks, he stands up and delivers an exalted fanatical speech, 'extending one arm towards the ceiling, eyes staring and intent', in which he refers to ancient Rome, Wagner and his miserable childhood, then remains standing 'arm raised in the salute to the heavens'.[36] But Beryl has the last laugh: as he goes to sit down, Adolf misses the chair, falls to the floor and disappears under the table.

At the end of the book, Adolf has to run through the streets in theatrical female garb. Humiliated by his disguise, he resolves 'to grow a moustache. Never again would he be mistaken for a woman'.[37] He will leave Liverpool and keep secret the fact that he has 'been to this accursed city, visited this lunatic asylum'.[38] When family and friends say goodbye to him at the station, a Jewish character called Meyer says of Adolf, 'Such a strong-willed young man. It is a pity he will never amount to anything.'[39]

Beryl's interest in Hitler continued for years to come. Among her papers were two pages from *The New York Times*: one, with photos of the house where Patrick lived, together with an article about him and his sons; the other, showing Hitler's tomb (quite a grand affair). Apparently Patrick went to live in the United States in 1939, where he joined his aunt Angela and enlisted in the air force. A play was written about him, entitled *Little Willy* (a nickname given to him by his father), and staged in 2006. The Führer

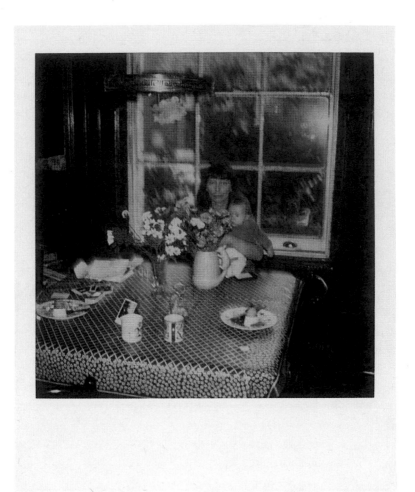

'We are a grandmother!'
Beryl with her first grandchild, Charlie, in 1980

referred to him as 'my loathsome nephew', but in Beryl's book, young Adolf appears quite loving and tender towards the child. Patrick had four sons, the article concludes, who are 'the last members of the Hitler paternal bloodline'.[40] On a scrap of paper she added that she lived around the corner from Patrick's birthplace. The 'night men', who figure in one of the dark scenes in the novel, did exist: they were from the City Corporation and came at night into the poorest areas to take children from their sordid homes to delouse and clean them in a bid to deter the spread of disease.

Young Adolf was a vehicle for Beryl to sublimate her obsession and to develop a personal doctrine on the nature of government and the responsibility a people must take for their history. She wrote to me in the winter of 1982, giving details of how the book came about:

> Weeks before it was published, I wrote an explanation of why I wanted to write the book – a sort of apology. I said it was because history liked to put entire blame on one person – Napoleon, Genghis Khan, Adolf, and make out they were monsters from birth. That way the rest of us could not be blamed for what happened, whereas we are all culpable in one way or another.[41]

Beryl was principled and held strong opinions. Although reactionary by temperament, she said she could never vote Tory, as she liked to think that she came from a Liverpool working-class background. At the end of the summer of 1984, she wrote to us from the coal-mining region of Barnsley, Yorkshire, during the bitter miners' strike of that period: 'I have no idea where you are and even less where I am. I'm among brass bands and miners, being frightfully militant and defending Arthur Scargill. You'd be proud of me.'

<p style="text-align:center">*</p>

In 1980, a particularly rich year for Beryl, Winter Garden was published and her personal life gained a new dimension: she became a grandmother when Jojo had a son, Charlie. Beryl took to her new role with great enthusiasm. She had always loved children, especially babies: she could be quite embarrassing at times when she stopped mothers with prams in the

street to pay compliments and coo at the little bundle. On her deathbed she asked Rudi if she could bring her a little fat baby to cuddle for a minute.

Charlie grew into an intelligent and beautiful boy. Bertie was born three years later, equally talented. It wasn't until 1993 that another grandchild, Inigo (Rudi's first son), was born; so inevitably Charlie and Bertie enjoyed their grandmother's undivided attention for a long period of time and their memories of her are more developed. They found considerable inspiration and encouragement in the relationship. Charlie, her oldest grandson, says that she gave him and his brother the feeling that everything was possible, 'and that creativity for its own sake coming out of your head and your own past...was the real meaning of life'. He remembers arriving at her house with Bertie 'to find the room on the top floor transformed into a blacked-out spaceship, with home-made altimeters, tin-foil gear sticks and an eerie soundtrack playing on her clapped-out tape recorder. All ready for our voyage to the stars.' He also remembers her offering doilies for them to draw on when there was no paper available. The music that Beryl liked to share with them included the soundtracks of *Mary Poppins*, *The Producers* and *The Charge of the Light Brigade*, played over and over again while 'she lay prostrate under a coat on the sofa, her bare feet poking out, a cigarette attached to her top lip'. She even built a puppet theatre and set them projects and plays to perform, choosing subjects such as the sinking of the *Titanic* (Bertie remembers making a model of the ship), Scott of the Antarctic and, Charlie laughs, 'Hamlet, of course'. She worried over the scripts that she wrote for them, and was prone to 'finishing off the sets when my brother and I got bored', says Charlie. The grand finale happened when 'she invited her most esteemed friends – Melvyn Bragg, A. N. Wilson, Terry Waite' to watch.[42] When I challenged him on the truth of this last statement – as I recalled that Beryl hated inviting the adults to these events – Charlie explained that perhaps it was 'a childhood memory, enthused with the spirit of Beryl'.[43]

Beryl in Albert Street
with Jojo and her two boys, late 1980s

'A ferocious – if morbid – imagination'

1984–93

Beryl had always been captivated by the wit and erudition of her publisher, Colin Haycraft, and under his increasing influence she began to write fiction based on historical events. Her novels are thus generally described as belonging to three different periods: the ones based on her Liverpool years; those informed by life in London; and, finally, those inspired by real characters who participate in publicly known events. The considerable research involved in the execution of the latter works meant that they are less numerous than the autobiographical novels as she needed more time to complete them.

Although death features in several of Beryl's earlier books, it tends to be as a plot device, or described in a blackly comic style. But in the 1984 novel *Watson's Apology*, death by murder is central to the plot and anticipated by the reader from the outset. Yet this is not a tragedy that has grown in meaning and relevance over the years – such as the sinking of the *Titanic*, the fateful trajectory of Scott's Antarctic expedition or the bloody battle of the Crimean War. *Watson's Apology* is not a depiction of those 'iconic moments in Western history' of which we read in the Preface (see page 7); it is a domestic, intimate tragedy that could happen at any time, and takes place in a typically bourgeois setting.

Beryl wanted to investigate and analyse the psychological and social reasons that led to such a turn of events. As part of her research, she asked me to drive her to the location of an historic murder in Stockwell, but it was only from the copy on the book cover that I learned that she had been the first to delve into the Home Office files documenting the trial and

Beryl with Colin Haycraft, early 1980s

sentencing of John Selby Watson, who in 1871 murdered his wife in a fit of rage by hitting her repeatedly with the butt of a pistol. Beryl kept secret her visits to the Home Office to look at the files, which had never been seen before. She used them to reconstruct the murder story as a novel; and so began a newfound passion for historical research.

The title of the novel came from Colin, who gave her a book called *Watson's Apology*, an edition of Bishop Watson's 'Apology for the Bible' published in the late eighteenth century in reaction to Thomas Paine's *The Age of Reason* (1794–1807). In Beryl's novel, the narrative describes the breakdown of a marriage between the Reverend J. S. Watson and Anne Armstrong, an Irish woman living in south London. When Watson first sees Anne he falls instantly in love, and is anxious to meet her again to make her acquaintance with a view to marriage. Once married, however, Watson appears unable to externalize his desire. Anne begins to resent her situation: if only she could consider her circumstances as temporary, she would submit cheerfully. She is lonely in the house and bored: 'the boredom', she explains, 'arose not from an inevitable withering of love but from her inability to affect him.'[1] He is too involved in his work, teaching, writing biographies and translating from Latin and Greek. She sees him as a pedantic scholar who can only quote from the classics. (Beryl indulges a

fascination for Latin: in this context, Colin's influence is again evident, as he had enjoyed a classical education.)

The situation in Watson's home becomes increasingly bitter and quarrelsome. He meditates, 'I hate and I love,' quoting verses from Catullus in his accustomed scholarly fashion. He accuses his wife of inadequacy and wishes she would leave him alone. But 'by some atrocious quirk of fate he had become her whole life. Whatever emotion she had substituted for love, it now consumed her.'[2] He refutes her profession of love, however. Meanwhile, disappointments mount up: Longman, the publishers, show no interest in his latest manuscript on the lives of the popes and he loses his job as a teacher. He blames marriage for his failures.

As the narrative unfolds, the reader can guess at what is coming. Why does Watson order a trunk to be made, and why does he throw away a stained handkerchief? Is that really wine on the skirting board? Why is there blood on his shirt? Then he exits to the locked room behind the library and the reader is spared a view of the corpse.

After the trial, Watson is taken to Parkhurst Prison, where he is denied access to literature. Lacking intellectual stimulus, he begins to create elaborate images in his mind and constructs scenes that echo episodes of his life. Beryl once told me that on many occasions she had created such vivid fantasies that she would cry or tremble with fear.

She produced an artwork that illustrates her fascination for the murder story: she took a late nineteenth- or early twentieth-century image of a church, printed onto glass, and scraped away the paint on the reverse to form a clear window in the main wall of the building. Here she added the image of a man with a dagger, about to strike his victim. The peculiarity of this image is that it has to be hung on its axis to be viewed. Rudi likes this work; she told me she finds it kitsch.

*

There was a gap of five years before Beryl's next novel was published, during which time she dedicated herself to compiling essays, commissioned by BBC TV, about the ways of life and people in various parts of England. She revisited the seminal work by J. B. Priestley, the great English author and broadcaster whom she greatly admired and who died in August 1984.

A Moment of Madness, 1984,

in which the murderer is about to stab his victim

To research and write *English Journey: or The Road to Milton Keynes*, which was published just over fifty years after Priestley's original (of the same title), she joined a BBC camera crew to retrace his steps and record the changes that the decades had brought. Another series of essays, which also became part of a television series, challenged the alleged divide between north and south. These were collected in *Forever England: North and South* (1986). Fond memories of Liverpool feature in both these volumes.

The research for these books involved a good deal of travelling from place to place, which Beryl did under duress because she hated to leave her children (and their little ones), home and garden. She was also involved in promotions for her novels, lecturing at various literary institutions for courses on creative writing and giving talks in different schools. Beryl was unable to say 'no' to any invitation. She would return exhausted from various trips and wonder why she had committed to them in the first place. She hated flying so much that eventually she refused to get on a plane, but her train journeys were adventurous. Once, a woman opened the door to the toilet where she was sitting, apologized, closed the door and opened it again a few seconds later to excitedly exclaim, 'You must be Beryl Bainbridge!'

When away, Beryl liked to send postcards; and I have discovered that many of her friends received similar missives. She chose old-fashioned images of strange, romantic or curious scenes that gave no indication of where she was. Among my collection of her cards I have a quirky one entitled 'A Spinster's Reverie'; in it she says very little other than to ask if I could get her some dark brown tights. Another shows a bride in traditional Bavarian costume of the 1860s. Yet another features a housewife wearing a pinafore and standing in front of a bay window; on the reverse, Beryl complains that she is going grey – her hair has become 'multicoloured'. She was concerned by that and worried that her hair was beginning to thin, as her mother's did. In general, she greatly resented the process of ageing.

*

A Spinster's Reverie.

One of Beryl's postcards to the author,
depicting 'A Spinster's Reverie'

An 'inspired' postcard in which Beryl says
she has 'still not got home'

Another of Beryl's historic postcards

In 1987 Beryl met Brendan King, who was then working at the Freud Museum in north London. Lili Todes (see page 57), who had a connection to the museum, discovered that Beryl was one of Brendan's favourite writers and so arranged a meeting at Beryl's house. There Brendan, who had already read all of Beryl's published work, made an enthusiastic offer to work for her. His role was initially secretarial, but soon extended to reading through her manuscripts as she wrote them; they began collaborating on *An Awfully Big Adventure* (1989). He discussed new projects with her and accompanied her on research trips to gather information. Eventually he typed up her manuscripts:

> When Gertrude at Duckworth, who at the time typed up the
> manuscripts, left in early 1990, I took over the typing, and
> Beryl and I worked out a kind of system, which began with

An *Awfully Big Adventure*, published by Duckworth in 1989

Every Man for Himself (1996) and continued for the subsequent novels. After Beryl had written a few pages she would send me a printout, which I would then type up properly, making notes of the various things I had issues with or questions about. We would then go through these issues and my master copy was amended according to whether Beryl agreed or not. This would keep going on with each subsequent section until the whole novel was written.[3]

Brendan also adds that the procedure had to change for the final novel, *The Girl in the Polka-dot Dress* (2011), because it was unfinished: he 'had to edit the existing material in a way that gave it a more conclusive narrative arc'.[4]

*

Beryl returned to memories of her early Liverpool days in *An Awfully Big Adventure*. With hindsight, the novel's position in her canon, coming after *Watson's Apology* (the precursor of a series of historic novels), is surprising. The title for this autobiographical work is a quotation from J. M. Barrie's *Peter Pan*, about the drama of loving and the adventure of dying.

When Beryl worked at the Liverpool Playhouse as an assistant stage manager, she fell most romantically and hopelessly in love with a stage designer (see page 31). In *An Awfully Big Adventure* the main protagonist, Stella, is in love with a stage manager, Meredith Potter. Stella's uncle Vernon describes her as having 'a ferocious – if morbid – imagination',[5] and she admits: 'I mourn people in my head. I go to funerals and chuck earth. Sometimes I have to choose who I am going to bury';[6] so much so that she has learnt to keep 'things locked up'[7] in an attempt to forge an independent life. The theatre, of course, provides the perfect backcloth to her vivid imagination as she rehearses the experiences of life. She is swept into a world of alternative reality and make-believe.

Beryl's description of the atmosphere – the tension and exhilaration of the performance, the language of drama, the whirlwind of characters, with their opinions, complaints and amorous intrigues – makes us realize how important her brief theatrical experience was to her development as a writer and painter.

The first section of the novel is mainly dedicated to describing the production of George Bernard Shaw's play, *Caesar and Cleopatra*, in which Stella takes the part of young Ptolemy (just as Beryl did; see page 31). Backstage, we witness moments of extreme disappointment, gossip and camaraderie. Stella is eventually accepted in the dressing room, and is initiated into the secrets of the theatrical world, from the application of make-up to the versatile effects of footlights.

The narrative then turns to the production of the pantomime *Peter Pan*, based on the stage-play and book by J. M. Barrie. Before the first rehearsal, Meredith warns the actors that he is not interested in 'Mr Barrie's emotional development': he regards 'the play as pure make-believe' and has no 'truck with symbolic interpretations'.[8] Beryl, on the other hand, explores the dark side of Barrie's fantasy and draws a parallel between Stella's loneliness and that of the 'lost boys' and the tragic end met by Tinkerbell.

Whenever Stella wants to hear her mother's voice and confide in her, she telephones the speaking clock. Yet we discover that Stella is in fact an illegitimate child, abandoned by her mother: the telephone contact is imaginary. Her mother, 'the girl with the golden voice', had been chosen by the General Post Office to become the voice of the speaking clock. Meanwhile, events in the theatre have brought Stella into contact with the very man who seduced her mother, the actor O'Hara, who is called in at the eleventh hour to take over the roles of Mr Darling and Captain Hook in the pantomime. He is strangely attracted to Stella, as if he subconsciously recognizes her. Unaware that he is her father, Stella willingly allows him to make love to her, and is even matter of fact about her first-ever affair (it had to happen sometime, she tells herself). He becomes more and more involved until he finds out the dreadful truth. His tragic death is synchronized with the final scene of *Peter Pan*. Tinkerbell has drunk the poisoned medicine meant for Peter Pan and is dying; her light is fading. She will only survive if the children in the audience clap their hands loudly enough to show that they believe in fairies. Backstage, Stella, who is in charge of shining the stage light on Tinkerbell, is overcome by the news of O'Hara's death and lets the torch drop to the floor. The light goes out: 'For a moment the clapping continued, rose in volume, then died raggedly away.' We can no longer believe in fairies, the novel seems to conclude, and we are left in 'a tumult of weeping'.[9]

<p style="text-align:center">*</p>

In the next three novels Beryl's imagination was fired by tragic episodes in history. Death becomes the primary theme in the narrative. The first of these was *The Birthday Boys* (1991). It describes Scott's expedition to the South Pole, an episode that had haunted Beryl's imagination for some time and led her to complete several associated paintings.

During their time together, the five men of Scott's Antarctic expedition team celebrate their birthdays: Beryl uses this device to link the five sections of the book, each narrated by a member of the expedition. The narrators' intimation of death is made all the more powerful by references to plans for their return. The title of the novel has a particular poignancy for the character of Captain Oates, who chooses to crawl from the safety of a tent into a blizzard to meet his death on his thirty-second birthday.

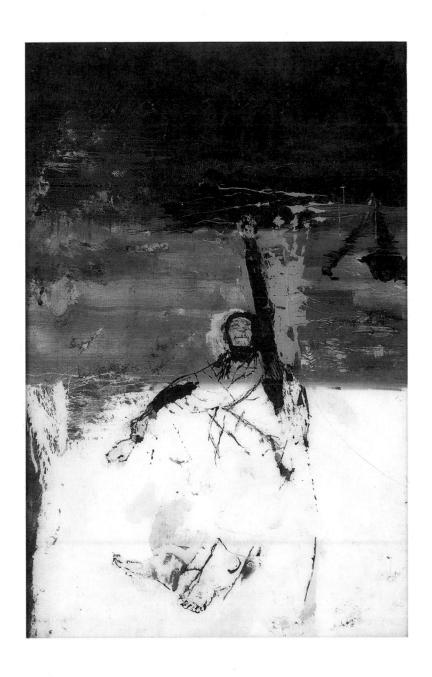

Captain Oates: 'I may be some time.'
Early 1990s

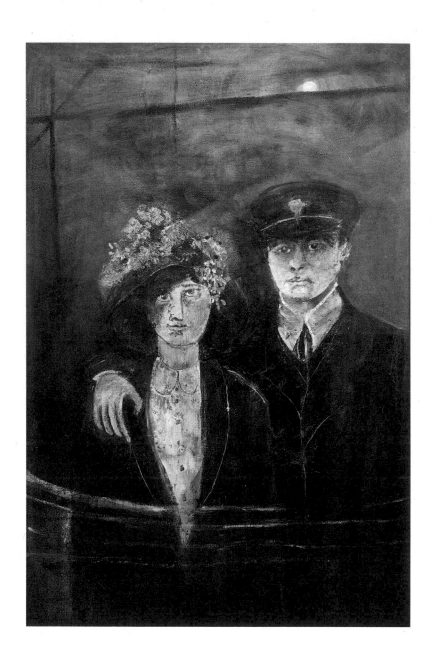

Captain and Mrs Scott, early 1990s

The novel invites us to identify the causes of this tragedy. Was Scott's choice of ponies as transport fatal, or did the eventual failure of the motor engines used to drive the sledges lead to misfortune? Or perhaps it was the last-minute addition of Taff to the team that sealed the fate of the expedition? We read of the supreme effort made by these 'half-starved and almost frozen' men, who were ruthlessly driven by their uncompromising leader to be the first to reach the South Pole; they were in a race with their Norwegian counterparts, led by Roald Amundsen. The Norwegians won: 'And then Birdie spotted the black flag.'[10] There is a simple pencil drawing of the Norwegian flag, made by Edward Wilson and dated 16 January 1912; its title is *Amundsen's flag at South Pole*.

The non-fiction work *Scott & Amundsen* (1979) by Roland Huntford[11] was vital to Beryl's research for *The Birthday Boys*; we know this because she gave Philip her annotated copy when he was going to Antarctica to paint. The thesis is that Amundsen was better equipped, both physically and temperamentally, for the task; he was certainly more democratic in his treatment of the Norwegian expedition team. Huntford claims that Scott took for granted that favourable weather conditions would last, leaving no margin for safety if they didn't. He also points out that Scott's depressive personality compromised his judgment and led him to make poor decisions during expedition planning.

Beryl drew considerable artistic inspiration from writing this novel and illustrated some of the written scenes. She painted a conventional portrait of Scott and his wife Kathleen, posing together just before his departure, with the rigging of a ship visible in the background. He is in full military uniform, with his arm around his wife's shoulders, looking into the distance. She is a handsome, elegantly dressed woman (as described by various narrators in the novel); she looks directly at us. Scott says of her: 'If I had met her when I was younger I would almost certainly have wished to die for her. Now I want to live.'[12] Taff sees them together at a ceremonial dinner in Cardiff prior to their departure and says, 'you could tell...they were friends not just husband and wife',[13] and that's how they appear in this painting.

Another of Beryl's paintings belonging to this series depicts three of the expedition team, Wilson, Henry Bowers (known as 'Birdie') and Apsley Cherry-Garrard, as they set off on skis to find an emperor penguin colony

and recover some eggs for scientific study. Icy rocks emerge from a cold-looking sea and the winter sun radiates white light in a polychromatic sky. The search for the penguins is very tough, given the persistent darkness of the Antarctic winter and a temperature of -40 degrees. Cherry gave an account in his book *The Worst Journey in the World* (1922). In *The Birthday Boys* it is Wilson who recounts the moment when they finally locate the penguins:

> We reached the cliffs seven hours later and descended a fair
> distance, cutting steps where our crampons couldn't find
> a foothold, scrambling over and under those gigantic growths
> squeezed up by the moving ice, only to meet a glacial wall
> which even a madman would have recognized as impassable.
> Like spiders we crawled sideways, and suddenly Bill shouted
> out triumphantly, 'Birdie, over here!', and there in front of
> us was a black tunnel burrowed into the ice, just wide enough
> for a man to enter.
>
> 'Here goes,' Bill said and we followed him, wriggling
> and slithering through that fox's hole until we emerged on
> a crystallised ledge above the bay. Below us uttering metallic
> cries of alarm and looking like so many overworked waiters
> strutted the Emperor penguins.[14]

Beryl painted a masterly image of this episode. She includes four figures (instead of the three men in the text); they are small but well defined against the mass of an ice cliff (described as 'a glacial wall' above). Birdie stands at the base of the cliff and is identifiable because of his unusual hat. A dim Antarctic light casts a rosy glow over the snow. Beryl manages to capture the different colours that emerge from the seeming whiteness of the frozen landscape. And she perfectly describes the Antarctic palette in the section of the novel narrated by Scott:

> Those who envisage this place as nothing more than a forsaken
> plateau of ice and snow are mistaken. For one thing there are
> outcrops of jet-black rock about which the wind blows so fiercely
> that the snow can never settle; and for another, the ice being
> subject to reflections of sun and sea, is never purely white but
> tinged with rose and cobalt blue and every shade of violet.[15]

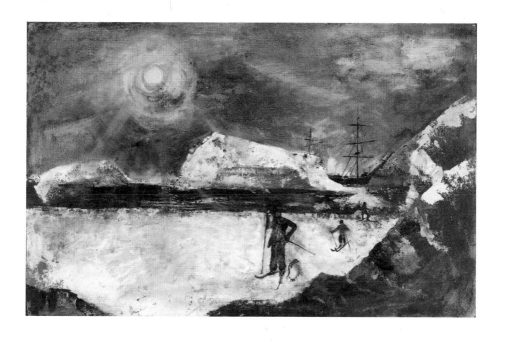

Beryl's portrait of Wilson, Bowers and Cherry in search
of emperor penguin eggs, early 1990s

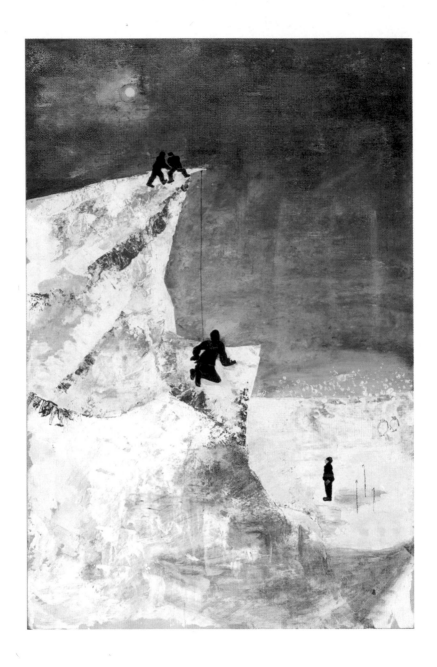

Beryl captures the colour palette of the Antarctic in this depiction
of the men conquering a 'glacial wall', early 1990s

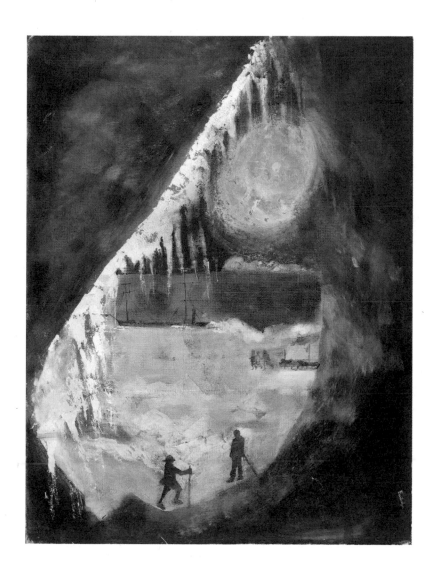

A moonlit Antarctic scene, early 1990s

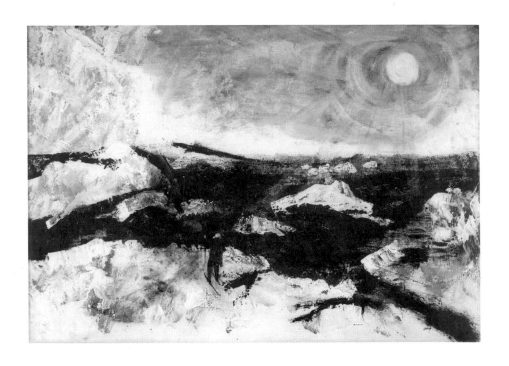

Beryl depicts 'floating chunks of barrier ice'
in this painting from the Antarctic series, early 1990s

She told me that as she was writing the book she would go out into the garden on a winter night, wearing only her nightie, to try to fully experience the sensation of being so cold.

Another of her paintings illustrates Scott's description of a night march. In this mysterious scene the men set out in the moonlight, under a brooding sky. The *Terra Nova* (the expedition ship, intended for the whaling industry) is visible in the background. Five men feature: they are all without skis; three lead dog-driven sledges; two appear in the foreground, one of them identifiable as Birdie in his hat. The image is bordered by dripping icicles and stalactites, which hang from the edge of a cave.

Beryl describes in the novel how the expedition team face mounting difficulties: they lose some of the sledge-dogs to crevasses in the ice plateau; the health of their ponies is in decline; and the ice has begun to melt. As they set off on skis early in the morning to reach base camp, they see the broken shapes of huge floes on the distant horizon. At first, Scott thinks this might be an optical illusion, but drawing nearer they find to their horror that they are real floes: 'The sea was a seething mass of floating chunks of barrier ice.'[16] They are now separated from safety. Scott decides that fate is against him: 'nobody will ever convince me that the stars don't play a part in it'.[17] His despair is conveyed in Beryl's painting, which captures this epic moment. She shows a single, dark figure standing on the broken ice, faced with merciless black stretches of water.

Horror follows horror when, later, they try to haul the ponies across shifting ice and one plunges into the water. As the men are too weak to rescue the creature, they decide to 'end its misery' by striking its head with a pickaxe. Another pony falls into the water, and suddenly there are 'killer whales rising all around'. 'None of us will forget that nightmare scene,' concludes Scott. 'The ice chunks heaving in the black water amidst the bucking whales.'[18]

Beryl became recognized as an authority on the history of Antarctica and, when Philip was invited in 2000 to join the British Antarctica Survey for two months as a visiting artist, a new layer was added to his friendship with Beryl. They often found themselves invited to the same events. In 2005 they went to an exhibition of Edward Seago's paintings at the Scott Polar Research Institute in Cambridge. The work was completed during his Antarctic voyage with the Duke of Edinburgh. Two years later, at the

same location, they saw an exhibition of Scott's correspondence with his family, including a view of the moving final letter to Kathleen, his wife, and the appeal, 'For God's sake look after our people.'[19]

Although Beryl took an interest in the work that Philip did based on his visit to Antarctica, she hardly mentioned her own paintings on the subject. Years later, when he finally saw her imaginative representations of the Antarctic landscape, he was impressed by their authenticity, given that she had never been there herself.

Beryl wrote the foreword to *Scott's Last Journey* edited by Peter King (published by Duckworth in 1999), in which she gives full credit to the courage of the adventurers:

> Modern readers of these journals, acquainted with
> contemporary accounts of polar exploration, in which men
> clad in the latest insulated clothing, equipped with radios,
> lightweight sledges, and with the knowledge that an
> aeroplane could rescue them, will find Scott's account
> of the hardships endured and the bravery with which they
> met death unbelievable.[20]

She ends on an emotional note, referring to another personal hero, Peter Pan, who claims 'to die must be an awfully big adventure' when faced with the prospect of fighting his nemesis, Captain Hook. In conclusion she writes: 'Amen to that.'

*

Beryl was always generous with her time, no matter how busy she was with her own work. In 1991, the same year that she published *The Birthday Boys*, she received a visit from Terry Waite, internationally admired as a campaigner for peace and humanitarian causes. He had just returned from Lebanon, where he had gone to negotiate the release of hostages but instead was seized himself and held captive for four years. During his imprisonment, he had written a book in his mind (he was denied pen and paper). Once free, he wanted to write it down but lacked confidence. As an admirer of Beryl, he asked if she could offer support. 'Write from the heart,' she apparently answered, 'as I do.' With Beryl's encouragement, his book,

Taken on Trust, was published in 1993 and became a bestseller. A good friendship developed between the two authors as they shared a love and 'respect for language'. According to Terry they both believed that language 'breathes harmony into the soul', and he felt that 'she lit up my life'.[21]

<p style="text-align:center">*</p>

According to Father Graeme Rowland, who later officiated at her funeral service, Beryl occasionally visited the Anglican church of St Silas the Martyr in Kentish Town, near her home in north London. She was experiencing a religious reawakening; she had converted to Catholicism in her youth (see page 31) and loved to decorate her home with religious iconography. Father Graeme says that he 'clicked' with her at their very first meeting and she started to attend his church, sometimes taking her grandchildren. He pointed out an elaborate stone bracket on one of the walls of his church, which she had donated. After a few years her attendance dwindled, but Father Graeme says that she was a natural 'seeker of truth' and never ceased to believe in God. 'Faith was always there,' he says 'in the complex background of her life. The saints in her house are more than mere decoration.'[22]

Religion remained a subject about which Beryl was reticent: I never knew how serious she was when she sometimes asked me 'to light a candle'. She continued to enjoy Christmas carol services and the main religious occasions. When Father Graeme learned of Beryl's final illness, he went to see her. She asked for a mass 'in the old rites' at her funeral, contrasting with the popular music hall song sung at her graveside by friends and family (see page 113).

<p style="text-align:center">*</p>

In 1993 there was an enjoyable artistic interlude before the publication of her next historical tragedy. She met Francis and Christine, who run the Francis Kyle Art Gallery in central London, and they invited her to take part in a group exhibition, even though her style was quite different from that of other exhibiting artists. The show was called 'Charleston Revisited: A New View of Bloomsbury in the Country'. Beryl agreed to participate

and made a trip to East Sussex to research the country home shared by the Bloomsbury group, which has been preserved for the public. The spirit of Charleston suited and inspired her to paint some fun scenes. She experimented with painting onto the surfaces of furniture (a Charleston tradition) and sold a decorated three-tier table, which she had picked up in Camden Market.

Of these paintings there are two by Beryl listed in the catalogue: *One Hell of an Afternoon at Charleston* and *In Maynard's Room*. In the former, a woman has stabbed a man, who lies on the floor, bleeding copiously, eyes and mouth wide open, with a black dagger across his pale chest. She wears a veil, only just concealing her voluptuous body, and is seated near her victim. She grips a heavily patterned rug. A yellow bust of a man with a peaked hat looks on with indifference, if not disdain, and a shaft of light cuts across the image, while the window on the other side of the room is dark. The details – including the cupboard door decorated with flower-pots, an upright wall panel, the red rug and blue flowers – place the scene at Charleston.

John Maynard Keynes, the great economist and member of the Bloomsbury Group, had a room at Charleston and eventually moved to a house nearby. Beryl chose his room as a setting for a post-coital scene, in which very little intimacy seems to have been achieved: the man slouches on a chair, eyes shut, looking weary; the woman sits on a bed, with her back turned from the viewer. Beryl has included a portrait on the wall, showing a neatly drawn man wearing a hat, which has a familiar, classical look. A menacing shadow cuts across this composition too. All in all, her contribution to the exhibition brought a sense of fun to the event and she managed to capture the energy of Charleston in her subject matter and stylistic execution.

*

Over a period of six years – from 1987 until 1993 – Beryl wrote (and later illustrated) weekly articles for the London *Evening Standard*. Despite her great success as an author, she never seemed to make enough money, although she wasn't extravagant in her style of living; this work supplemented her income from writing fiction. These were light articles, but they

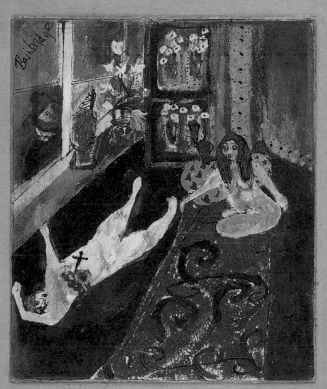

One Hell of an Afternoon in Charleston, 1993

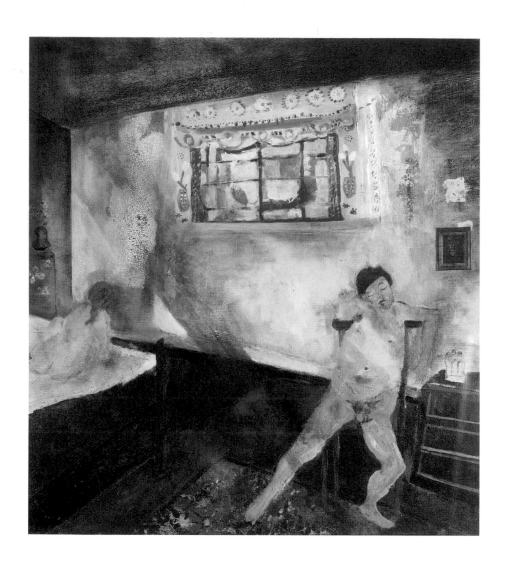

In Maynard's Room, 1993

do give further insight into her personality and include vivid descriptions of her family life. They are coloured by her sharp observations and delivered with a shrewd sense of comedy.

She collected a selection of these pieces into the book *Something Happened Yesterday*, published in 1993. In the preface she explains how she had to learn about this style of writing, because 'an article of eight hundred words was thought to be tiring on the reader, far better to break it into three or four bites on different themes'. She also realized that 'to grapple with so-called burning issues' was not going to be suitable, so she decided to 'embark on a circular ramble, starting and ending with memories of long-gone times and sticking London in the middle'. She felt that the articles 'read like a diary', and described them as 'indulgences for which [she was] being paid'.[23]

We learn a little more about her opinion of art: she visits the Tate gallery (now Tate Britain) to view a Picasso exhibition and pick up a few tips, but she wasn't impressed: 'All Picasso's women have very large bosoms, not always in the right place, and the Henry Moores on the lower floors were full of holes,' and she draws a comparison with her one-and-only, failed attempt at sculpture, a plaster model of J. M. Barrie.

At other times she directs the satire at herself: for example, she worries about her lack of physical exercise. What to do? Go to a swimming pool? But by using 'water-wings' (because she couldn't swim) she might attract interference from an overly enthusiastic instructor. Walking? She doesn't get out much. Tennis? She tried that, but found that she was getting through a packet of ciggies, while the other player was 'ferreting for balls in the bushes'. 'The only avenue, or rather square, left to me is my backyard,' she decides. 'Here I can plant and dig, bend and squat, tote that barge and lift that weed to my heart's content.' All sounds plausible and laudable until she confesses: 'I can't tell you the exact measurements of my garden, but it might fit into an average-sized bathroom.'[24]

She makes a joke of her explicitly urban environment:

My part of town does not go in for landscape gardening,
though we try, oh how we try. Next door nurtures roses,
man-sized cabbages, boy-sized Michaelmas daisies
and family-sized washing. On the other side we have

> a tasteful display of unpruned rubble, late-flowering
> piping, rampant old iron and...a rather rare specimen
> of a toilet bowl.[25]

Yet Beryl's garden was always very attractive and, when nature disappointed, she would stick plastic flowers onto sterile bushes and barren trees.

Some of these articles were based on her experiences while staying with us in Provence. She described meeting an old French general, who had once been very active in the Resistance, and had travelled by helicopter. He told her the history of the village, and showed her the tomb of one of Napoleon's generals, who instituted state education in France. She also described an invitation by other friends in the village to take part in a game that involved speaking to the corpse of Napoleon and asking him three questions. Being 'very keen on Bonaparte', she willingly ran up to the attic of their house where 'Boney was lying on a trestle table, bound head to foot in white cloth'. All she could see was 'the outline of his noble nose'. She began asking her questions but as she reached the third one, 'he let out a roar, reared up from somewhere behind me and tried to throttle me'.[26]

She describes teaching at a writers' residential course, something she did on several occasions. Her daughter, Rudi, asks if she might accompany her? Yes, on condition she doesn't laugh. (Rudi insisted on being introduced as a tree surgeon.) Beryl exclaims, 'You have no idea how many thousands of people up and down the country spend their spare time writing novels, poetry and radio plays.'[27] She also recounts the curious episode of the three Beryls when she joined the actress Beryl Reid in a discussion about the paintings of Beryl Cook for the television programme *Review*. Flushed with 'mugs of whisky', the two critics observe the 'upright poles in her work' – they must be phallic symbols, they say. Beryl Bainbridge admires 'a lovely painting of a lady flasher exposing herself in a fur coat to a mild looking gentleman in a bowler hat', which she interprets as 'an imaginative housewife meeting her hubby on his way back from work and putting a little excitement into the marriage'.[28]

Her domestic life provides another rich vein. She employed:

> two cleaners, one of whom is my daughter, a secretary,
> and a handy man. As the latter is my son he often leaves
> in a huff in the middle of some improvement. As for the

Eric the buffalo in Beryl's entrance hall

second cleaner, she often becomes tired and emotional half way through the afternoon and, duster in fist, passes out on top of the landing.[29]

Despite the presence of many stuffed animals, Beryl's house was remarkably tidy. She may have given the impression of leading a bohemian existence, but she told me that she could not start work until the dusting had been done and everything was in its rightful place. As we know, Beryl was often interviewed on the radio and at home. She enjoyed a good rapport with journalists, many of whom she invited into her house. They had to squeeze past Eric, the stuffed buffalo in the entrance hall, and often had a good look around, commenting on her many curious artefacts. Beryl was usually kind to them and generously answered their questions. And they liked her.

The articles in *Something Happened Yesterday* are peppered with touching personal remarks: 'There are people of sixteen, and I was one of them, who are perfectly capable of managing on their own, and I only wish my own parents had hit on such a satisfactory arrangement, rather than forcing me to run away.'[30] Equally touching is her account of going to the airport with her three children to meet Austin, her ex-husband of sixteen years. 'It's strange how people mellow with age,' concludes Beryl. 'We haven't had a cross word since he arrived, and he's out there now with his little hammer mending the fence. For my part I am doing quite a bit of dusting, though as yet I haven't felt compelled to burst into song.'[31]

When she visits the zoo with 'Darling Bertie', then the youngest of her grandchildren, his effect on a chimp is 'downright awe inspiring'. They stood 'mouth to mouth...for at least five minutes, gazing cross-eyed and besotted at one another'. Beryl supposes that Bertie could have been mistaken for a hunter, 'but surely anyone could see he was an exceptionally small big white hunter and he was carrying his pink juice cup'.[32]

Beryl's portrait of Bertie and the gorilla
illustrating an article collected in *Something Happened Yesterday*,
published in 1993

'Off upstairs now
for more
wrestling'

In the summer of 1993 Beryl turned down our usual invitation to France, explaining: 'No good saying I can work there, not at the very beginning. I have to shut myself up alone, possibly with a bottle of booze, and struggle.' But she did go on holiday with Jojo, Charlie and Bertie, renting a house near Portsmouth, which was 'oak panelled and [had] huge green lawns and apple trees'. From there she gave us the happy news that Rudi was pregnant; she had bought her a super-sized bra in between dashing back from Scotland, where she had been lecturing, to Portsmouth, where 'all the boys want to do is to play skittles and billiards'. To complete her happiness, Bertie had 'just written a superb limerick'.[1] (Inigo, Rudi's first son, was born the following December.)

The holiday home in Portsmouth may have provided an auspicious environment for the early development of her next novel, but it wasn't until 1996 that Beryl finally published *Every Man For Himself*, an account of the sinking of the *Titanic* in 1912. Like Scott's expedition to the South Pole, the *Titanic* disaster had been the subject of her two elder grandchildren's creative projects (see page 128), and she remained consumed with the story for a long time after the completion of the novel; she was also inspired to complete several beautiful paintings on the subject.

The narrator Morgan is a young man with an already complicated life. Among the many baffling episodes from his past we read that his mother was allegedly painted by Cézanne, and he is smuggling this portrait from England (although it will go down with the *Titanic*). Beryl chose to be deliberately obscure in her novels, as she admitted to Lynn Barber:

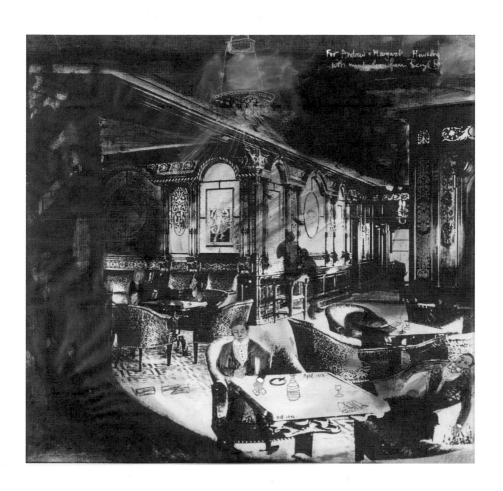

Last Dinner on the Titanic, late 1990s

Boarding the Titanic, late 1990s

I hate books where you read a page and you can tell what's
going to happen next. Mine are a bit obscure, I know,
but deliberately – you're supposed to go back and think,
'Well, did that really happen?' It's the way I think anyway.
Like I expect people to know what I'm talking about in
conversation – I know it, so why doesn't everybody else?[2]

The figure of Adele Baines, a lower-deck passenger, appears through-
out *Every Man for Himself*. Her first appearance, before boarding the liner,
is in the dining room of the South Western Hotel. She turns the heads of
several men, including, in particular, a character named as Rosenfelder
(referred to as 'the stout man'). He is a dress designer, with ambitions to
become a couturier at Macy's in New York:

> The stout man reached the door and half turned.
> The expression on his face was so open, his feelings
> of admiration, if not downright desire, so apparent, that
> I looked at the woman. She was singularly tall for her sex,
> statuesque in build, and wore a tailored coat of some
> dark material with a touch of cheap fur at throat and wrists.
> From her low-brimmed hat escaped a wave of bright hair.[3]

Beryl paints her in *Boarding the Titanic* against a romantic backdrop, which,
despite the title of the painting, has very little resemblance to Southampton
docks. She gave this painting to her friend and fellow writer, A. N. Wilson.

We later find out that Rosenfelder's interest in Adele is mainly pro-
fessional; he has designed a glorious dress and she has the right figure to
model it. She is also a performer, and she sings an aria from *Madam Butterfly*
dressed in Japanese costume. As the *Titanic* is about to sink, we see her
wearing the dress designed by Rosenfelder. The narrator catches a last
glimpse of her, lit by the glare of a rocket that has been sent up to summon
help: 'I glimpsed Adele curved like a mermaid with that glimmering train
swished aside.'[4]

In another painting related to the novel (see page 165), Beryl con-
denses the action by combining the moment of impact with the iceberg
and the actual submergence of the boat. More than half the ship is plunged
beneath dark water, while the remaining section shows brightly shining

cabin lights. The menacing iceberg and white foam stand out against the black water, and a clear night sky is dotted with stars. Figures, also painted in black and white, are visible on deck, gesturing helplessly.

Beryl's written description of the sinking is equally dramatic. The narrator is playing bridge with his young friends 'when suddenly the room juddered; the lights flickered and Ginsberg's cigarette case, which sat at his elbow, jolted to the floor. It was the sound accompanying the juddering that startled us, a long drawn-out tearing, like a vast length of calico slowly ripping apart.'[5] And two pages later: 'The first five compartments were filling and the weight of the water had already begun to pull her down at the bow.' The captain asks, 'How long have we?', and the answer comes: 'One hour and a half.... Possibly two. Not much longer.'[6]

The lights of the ship also feature in the painting *The Titanic Lifeboat*. They illuminate figures who have fled the ship and are hoping to be saved but also those who are still on board and will likely drown. Faces peer from portholes. Rudi, who likes this painting very much, explains:

> I remember [Beryl] saying when she was looking for
> photographs of faces to cut up and stick on – she was
> [a terrible one]...for cutting pictures out of books – that
> she thought of putting us in there, or the grandchildren,
> but then felt bad because the boat sank. I [suggested]
> she could have put us in the lifeboat. After all is said and
> done, Adolf [Hitler] as a child is there, and so is Mickey
> Rooney and Doctor Johnson.

She adds:

> I am impressed by the certainty of the composition: it
> suggests passion, lacking in a lot of her paintings, which
> is not to say that they are not good. I think probably she
> did this quickly; it flowed easily. I find the captain on the
> bridge under the sprinkling of stars, holding the megaphone
> in his hand to shout instructions for the rescue operation
> of the lucky few, touching. Finally, a man I could understand
> or like. I wish I had talked to her more about [the] success
> [of the painting].[7]

Beryl's depiction of the final moments
as the *Titanic* sank, late 1990s

The Titanic Lifeboat, late 1990s

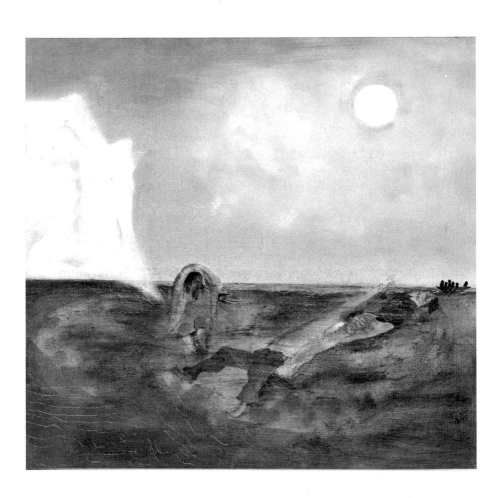

And When the Dawn Came, late 1990s

Another painting in this series relates to the final scene of *Every Man for Himself*. The narrator, who has jumped into the sea at the last moment, manages to survive the swell of the sinking ship: 'I don't know how long I swam under the lidded sea – time had stopped with my breath – and just as it seemed as my lungs would burst, the blackness paled and I kicked to the surface.... I was alive and about to breathe again.'[8]

In spite of the night, he manages to sight a lifeboat: 'Gradually I grew accustomed to the darkness and made out a boat in the distance away. Summoning up all my strength I swam closer; it was a collapsible, wrong side up and sagging in the sea'.[9] Although nobody in the boat is willing to help, he manages to scramble aboard.

In Beryl's painting *And When the Dawn Came*, the narrator is shown surfacing from beneath the sea, his eyes bulging from the effort of holding his breath. Not far away are two bodies, one bent across the other to form the shape of a mermaid. A painting with a similar title, *And When the Rosy Dawn Came*, features survivors in the lifeboat, small and vulnerable beneath towering icebergs and a vivid pink sunrise. This belongs to her former agent Andrew Hewson, and I imagine she first gave it to his wife, Margaret, who died in September 2002. Beryl was very fond of her and missed her deeply. She sent us the obituary and wrote:

> It is hard to feel anything at first after death, it being so curious. Here today – gone tomorrow. It is only four days later that I feel it – I mean that I want to see her again.
>
> I loved her; she did have a say in my career and once Colin had gone, she sort of took over in that respect. Now I'm on my own. You can say I always was. I think it is so with dying...her death...a reminder of my own, soon to come.[10]

Beryl's grief, and the inevitability of her own death, must have affected her youngest grandson, Luther, who was just two and a half years old. 'He came to lunch and announced that he didn't want to die. He must have overheard us talking about Maggie,' she explains. 'After that we were a bit alert, I can tell you.'[11]

*

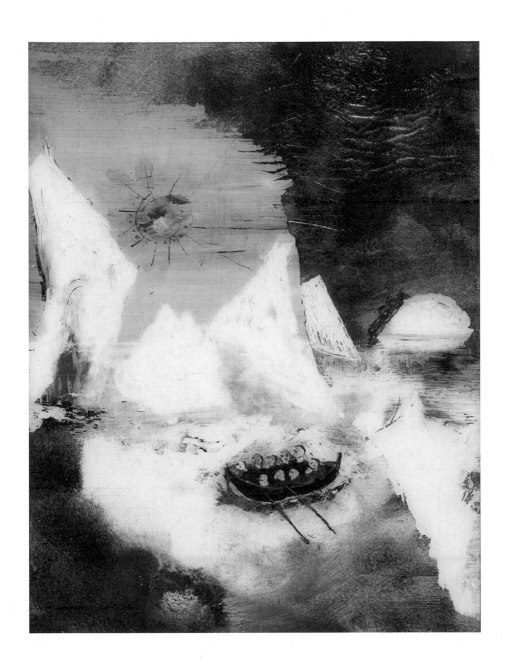

And When the Rosy Dawn Came,
late 1990s

Although much of Beryl's life was dedicated to researching and writing her major novels, she still found time for her large family, and she enjoyed socializing. She had many friends whose names she often rattled off, expecting me to know who she was referring to. The fact is that she kept her friends in different compartments and it was only after her death that I met some of them in person and found out that, for example, 'Brodie' was someone called Brian Taylor; 'Tim-tim' was Timothy Ackroyd; and 'Jimmy' was Jeremy Trafford. But I have known Lili Loebl and Cecil Todes as long as she did because we all lived in flats in the house on Arkwright Road in 1963 (see page 19). Beryl was intrigued by the couple, and looked forward to their dinner parties. Lili has always been a wonderful cook, but that was not what impressed Beryl: it was the brilliant company and conversation that she found so fascinating. She was particularly interested in Cecil, who worked at the Tavistock Institute of Medical Psychology. He treated children suffering from trauma, and subscribed to the theories of paediatrician and psychoanalyst Donald Winnicott on the importance of bonding with children and responding to their need for love – all subjects dear to her heart.

Beryl also enjoyed seeing the couple on their own, and sometimes Rudi, who shared her mother's fascination, joined her mother for visits. Lili tells me how Beryl was avid for information from Cecil, and never stopped asking questions. When he developed Parkinson's Disease, she was shocked to witness an intelligent, lucid mind become imprisoned in a deteriorating body. Talking became more and more difficult for him, until she could no longer stand to see him struggle to express himself, so she chose to stay downstairs with Lili. Cecil died in 2008.

Beryl was not a good sleeper and used to wake early. She refrained from going downstairs (so as not to disturb the woman who had bought the basement flat below), and remained in her bedroom, often listening to the radio. It is no surprise that she was so well informed about the political and artistic world: she had an amazing memory, especially for names, and it was difficult to keep up with her. When she did eventually get up, she would go out to do her shopping in Camden High Street, buying a little bacon, cigarettes and milk – that was her exercise for the day. She considered breakfast a serious matter, and cooked and ate it with pleasure. (The rest of the day's meals were dependent on whether she remembered to

Some of Beryl's family and a few
friends in May 2010

eat.) Then she would head upstairs past her bed/living room, where she would sometimes strike a chord or two on the old upright piano that she faithfully had tuned twice a year. Occasionally she accompanied the notes, invoking a few words of an old aria. Then finally, she'd make it to the top floor, where she would work. In her younger days she had preferred to work at night between eleven p.m. and three a.m., but her working hours eventually shifted to daytime. In the evening she descended to the ground floor to lie on the chaise longue in the dining room and watch her favourite television programmes.

*

On 19 April 2011 Beryl was awarded the Man Booker Best of Beryl Prize, a posthumous recognition of her deserving achievement. The Booker Prize Foundation invited the public to vote for one of her five books that had previously been nominated: these were *The Dressmaker* (1973), *The Bottle Factory Outing* (1974), *An Awfully Big Adventure* (1989), *Every Man for Himself* (1996) and *Master Georgie* (1998). *Master Georgie* was the chosen novel. It is her most compressed book, but after you have read its six chapters you feel that nothing more could be added.

Tragedy is impending throughout this novel: the dominant theme is that of death, with which Beryl had become increasingly fascinated. She was particularly compelled by thoughts of her own mortality. A number of her family members had died at the age of seventy-one, and she began to say, half-jokingly, that she too would die at this age. In fact she celebrated her seventy-first birthday in 2003 surrounded by her children and grand-children. Charlie filmed this occasion, and many more over the next few years, eventually putting them together in a documentary called *Beryl's Last Year* (first broadcast in June 2007 by the BBC).

As with her other historical novels, Beryl applied a good deal of research to the writing of *Master Georgie*, which recreates the British experience of the Crimean War in the mid-nineteenth century and is told through the adventures of the eponymous hero, George Hardy. She gives authentic descriptions of the Maltese and Turkish landscapes and the cultural traditions of these two countries, viewed on the journey to Crimea. The sequence of political events that led to the war, and the ensuing

battles and defeat, are well within her scope. Her research extended to the subject of photography; she describes Georgie's equipment and how he used it. 'There is something of black magic in the photographer's art,'[12] says Doctor Potter, one of the three main first-person narrators, in the course of the novel. Beryl loved playing with cameras, though she wasn't especially technically expert; sometimes she used a simple disposable camera. She was particularly keen on photomontage. In January 1995 we took a trip together in Aswan and Luxor in Egypt to celebrate the arrival of the new year by the Nile. There had been attacks on tourists, which meant that the place was quiet. She enjoyed the trip and smiled contentedly when riding on a camel, elegantly dressed in her navy blue coat from Oxford Street. Afterwards she presented us with amusing photomontage images of us swimming in the middle of the Nile or sleeping in King Farouk's bed.

Although there are no paintings related to *Master Georgie*, Beryl fills the narrative with descriptions of the landscape and people, and references to visual images. At the end of the novel she describes the taking of a photograph of the few surviving soldiers on the battlefield 'to show the folks back home'.[13] The group poses for the camera, and to balance the composition they prop up the corpse of Georgie in their midst.

Beryl and the author in Egypt, January 1995

The bed of King Farouk of Egypt. Photomontage created by Beryl
using a photograph taken on her disposable camera, 1995.

Master Georgie is the first (and only) book in which Beryl comments
on the cruelty and ultimate futility of war. At the end of the novel, another
of the three narrators, Pompey, is ordered to refill his ammunition pouch
and proceed with the 4th Division towards the Sandbag Battery. He
remarks, 'Quite why it was necessary to defend such a nothing place was
never explained.' And later he confesses that he doesn't know 'what cause
he was promoting or why it was imperative to kill'. Yet, when forced to
engage in a hand-to-hand encounter with a Russian, he finds 'it became
ordinary, commonplace to pierce a man through the guts'.[14]

Beryl gave a personal reaction to the occupation of Iraq in 2003:

Oh, that war! One feels physically sick. And have you seen
the things in the papers asking for money to help the injured
children. How dare they? Only John Simpson, who was
10 yards from a bomb going off (friendly fire?) and is now
deaf in one ear and has shrapnels in his legs, gives any true
reportage on the mess he confronts. And you can tell he has
been told to keep his opinions to himself.[15]

She also pointed out that war is not futile for everybody – there are those
who benefit from the devastation: 'Some wonderful articles in various jour-
nals reporting on the background of the Yankie people about to take control
of the reconstructive programmes. Each one has an invested interest and
was implicated in shady dealings years ago in the time of Bush Senior.'[16]

<div align="center">*</div>

Beryl was very distressed when Colin Haycraft died in the winter of 1994.
Her professional relationship with Colin had been to some extent sym-
biotic: he built her up as an author and her reputation as a writer grew
extensively; on the other hand, he (and Duckworth) relied considerably on
the literary success of such a prominent author. He had helped with her
research, especially with quotations from Latin, and improved her under-
standing of the essential differences between writing novels and scripts so
that she could adapt her novel *An Awfully Big Adventure* for the stage. It was
performed in Liverpool in 1992 and Rudi played the part of Stella.

Yet, strangely enough, Beryl admitted in retrospect that the death
of Colin liberated her. She explained in the interview with Lynn Barber
that 'by the mid-80s she had written out her own past and started casting
around for new subjects based on historical research'. Barber concludes
that the later historical novels are considered 'more mature' and even more
masculine: they have male protagonists, rather than female, and hold more
appeal to a masculine audience, in comparison with the autobiographical
novels. Beryl told Barber that she could not have 'written about Dr Johnson
while Haycraft was alive' because 'Colin was nuts about Doctor Johnson':
she claimed, he 'would have told me I didn't know enough'.[17]

Years before Colin's death, Beryl arranged for him to give Latin lessons to Charlie and Bertie. She attended these herself, and began a painting to illustrate the scene, which she later reworked (see page 182). The boys seem to think that they did learn something but it is all forgotten now. Having cut short her own school years, she was ambitious for her grandchildren's education, and was critical of teaching in schools. As far as she was concerned, anyone who spoke more than one language deserved respect, and she viewed the teaching of Latin as the epitome of a good education. She criticized the fact that the Church of Rome had abandoned Latin as the language in which to officiate. When I pointed out that the majority of the congregation did not understand the language any more, she answered that that was all for the better; it added to the sense of mystery surrounding religion. When she planned her funeral, she asked for the Latin rites.

Although Beryl was modest about the remarkable quality of her research, her achievements were publicly recognized and she was awarded several honorary degrees. She was touchingly thrilled when she received a degree from the University of Liverpool in 1986. She kept a photograph of herself, wearing her ceremonial apparel and smiling and walking with the Dean of the University, on the wall of her bathroom, behind the toilet. She also received an honorary doctorate from the Open University (2001) and the University of Stirling (2002). A photo taken when the latter was awarded shows how well the academic gown suited her.

*

Beryl became a grandmother again as Rudi and Aaron took turns to produce five more grandchildren: Rudi had three boys, Inigo, August and Luther; while Aaron had two girls, Esme and Florence. She loved all the children but insisted that she should not be called 'grandma' or 'granny', so she became 'Beb' to all of them. She often babysat for her children at their houses or had the grandchildren to stay overnight, which they loved because she was so indulgent and often took them to the cafe around the corner for breakfast. She drew great pleasure from watching them and listening to their conversations, and proudly wrote to tell me: 'Four babies came to stay last night, all in pyjamas.'[18]

Graduate of the University of Stirling, 2002

Beryl's next novel, *According to Queeney* (2001), proved a battle to write. Doctor Samuel Johnson, author, moralist and lexicographer who spent nine years producing his masterful dictionary of the English language, was a literary figure close to Colin Haycraft's heart; Beryl wanted to explore her mentor's fascination, and only felt confident in doing so after Colin's death. 'Off upstairs now for more wrestling. Computer working fine. Brendan [King] shook free half a ton of ash yesterday,' she admits.[19] In another letter she writes, 'It's taking me ages to write this book. When I'm finished...I reckon I'll need a blood transfusion.'[20] And again, 'Dr Johnson going on but oh so slowly. It's the language. They never used apostrophes. Nor did they use one word when five were available.' She concludes with a

smile: 'Not been out, not seen anyone, the Queen has not been in touch.'[21] However, the Queen did in fact honour her that year and made her a Dame of the British Empire. Beryl was pleased enough, although she made jokes about her status. She went to Buckingham Palace to attend the reception, shook hands with the Queen, ate cucumber sandwiches and talked to Prince Philip. The *Camden New Journal*, which never failed to keep up with events in Beryl's life, published an article with the title 'There is Nothing Like a Dame'.[22]

In *According to Queeney* Beryl dramatizes the relationship between the famous literary doctor and the wealthy Thrale family, who made a fortune from breweries and had a country house in Streatham Park. She tells the story of Johnson's love and esteem for the lady of the house, Mrs Thrale. Over the course of twenty years we witness the vicissitudes of their passion, rejection and mounting sexual tensions, all told against the background of a perfectly rendered Georgian London society. Doctor Johnson is involved in teaching Latin to Queeney, the Thrale's eldest daughter (they had twelve children, but only four daughters survived into adulthood).

Beryl describes Johnson's appearance through the eyes of various characters in the novel. This is how Mrs Desmoulins, a neighbour and former lover, sees him:

> He was dressed, though without shoes and stockings, and
> she noticed the angry redness of his feet. He looked her full
> in the face, yet he didn't see her. The sight of his stubbed
> cheeks, brow furrowed and eyes circled with darkness filled
> her with terror.[23]

And here is Mrs Thrale's view:

> The reality of Johnson in appearance and behaviour, the
> scarred skin of his cheeks and neck, his large lips forever
> champing, his shabby clothing and too small wig with its
> charred top piece, his tics and mutterings, his propensity
> to behave as if no one else was present, was at variance
> with the elegant demeanour imagined to be proper to a
> man of genius.[24]

Dame Beryl Bainbridge.
Photomontage created by Beryl, 2000

Then again, Mrs Thrale was no beauty either, although we do hear of her bright, intelligent eyes, and 'a certain winning intensity of manner capable of seducing the onlooker'.[25] Beryl occasionally wondered what sort of figure Mrs Thrale must have had after sixteen pregnancies; Beryl was proud of herself for staying slim after having three children. However, Mrs Thrale did have a skill for creating a convivial and inviting atmosphere in her Streatham home. She drew a coterie of notable figures – Oliver Goldsmith, David Garrick, Joshua Reynolds, William Hogarth, Fanny Burney and, of course, James Boswell (Johnson's biographer) – around her much esteemed guest, Doctor Johnson, and managed to lure him as often as possible away from his room in Bolt Court. She 'needed an audience',[26] as her daughter Queeney recognizes.

These gatherings, involving a mixture of gossip, witticisms and literary quotations, gave great pleasure to Mrs Thrale:

> She was pleased the party was proceeding so well. It was not
> always easy to promote a convivial atmosphere before the
> wine had taken effect, and well nigh impossible if Johnson
> happened to be out of sorts.[27]

Beryl would occasionally go to the Haycrafts' literary Sunday lunch parties, which lasted well into the evening. Colin sat at the table and his wife Anna joined in while cooking at the Aga with a whisky in her hand (according to Beryl's reports to Rudi). There, Beryl met with various literary figures – including A. N. Wilson, Freddie Ayer and Brian McGuiness – and in their company she became stimulated and enjoyed a drink. She happily became the centre of animated conversation – she was the 'court jester', in Rudi's words. Unfortunately, she never managed to hold her drink and ended up 'under the table' (in her own words) before the food was served.

Unlike Beryl, Johnson was not a heavy drinker, although many of his friends were. Beryl depicts him as a liberal man, who was extraordinarily forward-thinking in his ideas about the upbringing of children: he criticizes Mrs Thrale for her severity and for forcing precocious learning on her eldest daughter. He thinks that children should be shielded from the horrors of life, and holds an enlightened position in relation to capital

punishment. As he is fervently religious, he feels guilty about his sensuality and love for Mrs Thrale, which he finds difficult to contain.

The relationship between Johnson and Mrs Thrale is often seen through the eyes of Queeney, providing an opportunity for comic and naive misperceptions of their encounters: she observes them 'wrestling on the landing for the possession of a length of chain attached to some metal object'; and, again, she sees Johnson 'falling on to his back and she on all fours'. Queeney is asked to 'go to seek out the cat', having watched 'Mr Johnson at the fireplace' and 'Mamma smiling'. 'Neither spoke, yet thoughts passed between them.'[28]

Johnson is the subject of two paintings completed by Beryl around the time of writing *According to Queeney*. She restructured the painting of Colin Haycraft giving a Latin lesson to her eldest grandsons, adding the figure of the doctor standing by, as if to supervise. The two students no longer appear in this painting, but many little portraits are hanging in the room, including one of Johnson's late wife and one of Queeney. The figure of Doctor Johnson also presents a miniature image of Mrs Thrale as she appears in the portrait by Joshua Reynolds (1781), which he holds over his heart. In a second portrait, Johnson is sitting alone at a little round table with a blue bottle and a spray of flowers. He is lit by a chandelier above his head, and a window in the background reveals 'the moon like a watchful eye', as Jojo comments. Also on the table is 'a bloody great doily' (Jojo's description), and a black cat, named Hodge in the title of the painting. There is also a black cat in the novel, which belongs to Mrs Porter and weaves in and out of the rooms at Johnson's residence at Bolt Court. When the cat dies, Johnson writes to inform Queeney: 'So things come and go. Generations, as Homer says, are but like leaves, and you now see the faded leaves falling around you.'[29] In this portrait he looks disappointed, perhaps because his enduring admiration for Mrs Thrale was thwarted when she became widowed and chose to marry Piozzi, the Italian singing teacher.

In the final chapter of the novel, which is significantly entitled 'Dissolution', the Thrale household breaks down; Streatham is abandoned; and Johnson returns to Bolt Court to die. 'Disappointment was a big theme in [Beryl's] novels, though not conscious, I don't think,' Jojo

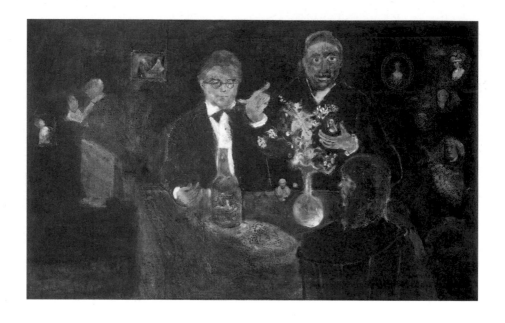

Colin Haycraft, Dr Samuel Johnson and Me, Learning Latin
in Gloucester Crescent, 2000

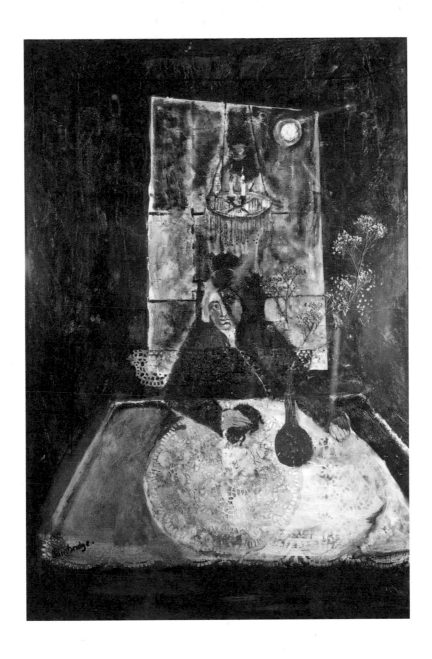

Dr Samuel Johnson in Albert Street
with his Cat Hodge, 2000

concludes.[30] In the earlier novel, *Injury Time*, Edward sums up Binny's love life, remarking: 'All the men you have met seem to have let you down. One way and another.'[31] How fitting as a description of Beryl's own experience. Of course, she enjoyed the success that her books brought, the interviews and articles, but how many times had she attended the Booker Prize ceremonial dinners, anticipating that she was not going to win despite the nominations? She did win other prizes: in 2003 she was awarded the David Cohen Prize for Literature, but on that occasion she wrote to me to complain, 'I got a letter on Friday from Cherie Blair in handwriting congratulating me on that prize I got. I wrote an effusive reply thanking her, and then tore it up.'[32] It was not the ultimate prize that she so wanted and deserved.

*

On top of disappointment, she dreaded the onset of writer's block, when the book wasn't coming. Her work process involved sitting at an old school desk, jotting down ideas with pen and paper, then transferring them to typewritten pages. Initially she used a manual typewriter, and later worked with an old-fashioned Logica word processor (which she managed to keep going thanks to the assistance of a Logica engineer who admired her work) until she was forced to move to a more modern computer. Her Logica model can be seen in the Science Museum, London, and Beryl's own machine is on display at Logica's headquarters. Her attitude to technology was always one of diffidence, bordering on resentment: she felt that she could no longer 'write in pencil or pen, word processors do something to the handwriting as well as to the brain'.[33]

Beryl's courage and persistence became clear to me when, despite the success of *According to Queeney*, she lacked the energy and inspiration to conceive a new novel, which meant that she had very little to live for. Yet, in answer to my admission that I felt suicidal at that time, she wrote:

> You so upset me when you said you wanted to die. I mean,
> I do too, but I'd prefer to go before you. I'd miss you to put it
> mildly. Suppose what we suffer from is too much of a good
> life. If we were poor or uneducated we would be too busy

surviving or just existing to long for death. Such longings belong only to the depressed or to those who know what life had once to offer. Please cheer up. You are my dearest friend and I rely on you.

And then, typical of Beryl, she adds: 'However if you really need me to stand by with a pillow, I will, reluctantly.'[34]

'Must finish
this bloody book'
2005–10

In 2005 Beryl published *Front Row: Evenings at the Theatre*, a selection of theatre reviews (from 1992 to 2002) written for *The Oldie* magazine, founded by Richard Ingrams in 1991. In the introduction to the collection she states that she was on board from the outset: 'Fired by Richard's enthusiasm, I… volunteered to write the theatre reviews.' These articles confirm Beryl's lifelong devotion to the theatre. She reminds us that her connection with the performing arts dates back to when she was 'eleven or twelve' and took part in the *Northern Children's Hour* radio show. Then there was her time at the Liverpool Playhouse, where she took on small acting roles. The following year she took part in repertory seasons, travelling to London, Dundee and Windsor. Brenda Haddon tells me that she also wrote and read stories for BBC Children's Hour centred on a character called 'Ceedy Man', for which she was paid £1 per minute.[1] In her 1961 appearance in the television soap *Coronation Street*, she played alongside the character of Ken Barlow as they prepared a 'Ban the bomb' poster for an anti-nuclear protest march. She remained a faithful viewer of television dramas – particularly the soaps, which she discussed on the phone with Bernice Rubens, as I witnessed on a few occasions. I was surprised to hear them talking in intimate detail about the characters from different soaps, as if they were friends known to both. When I asked about these phone calls, Beryl explained that Bernice was a friend and a colleague she had met when they both lectured at creative writing courses across the country; they had discovered a shared passion for television drama.

Beryl's television set was a curiosity. She hired it over the course of some twenty years, despite her children telling her that she could have bought the latest model several times over with all the money paid to the hire company. But she didn't want the latest model; in fact, she resented the arrival of coloured images on her screen and tried to revert to black and white. She kept the set, which was small, high on a shelf in a veneered cabinet, and viewed it as she lay on her chaise longue.

Beryl was extremely loyal to those who ventured on the stage as actors, directors or producers: 'I have found it impossible to condemn out of hand anything I have seen in the last eleven years,' she says. On the contrary, her witty and intelligent reviews show how she never stopped feeling a 'certain magic' when going to the theatre, as she 'entered that world of make-believe'.[2]

The *Front Row* collection is presented in chronological order, with a chapter covering each year. At the start of each chapter, she honours people from the mainly British theatre or cinema worlds who died during the course of that year. The reviews cover all aspects of a performance, from text, acting and production, to musical accompaniment and, sometimes, the theatre itself. Beryl is full of praise for the Roundhouse in north London: 'built in 1846 as an engineering maintenance and turning shed for steam engines.... I was blown away by its magnificence.'[3] She describes the modern reconstruction of Shakespeare's Globe, on the bank of the river Thames, as 'a glorious circular edifice',[4] but is quite scathing about the Barbican, declaring it to have 'the ugliest interior of any building in London'.[5]

The pages of *Front Row* give regular reminders of events in Beryl's life, which she shared with friends. On one occasion she reports from the theatre festival in Avignon, France, on behalf of *The Oldie*. She attended a performance of two actors improvising dialogue on themes suggested by the audience. They were asked to recreate a scene 'in the manner of Beckett', which involved sugar lumps slowly melting into cups of coffee. Beryl freely admits in the review that she doesn't know much French, but she declares the mime to have been so effective that she thoroughly enjoyed herself and shares her evident pleasure with readers.

In a touching personal episode, she reviews the play based on her novel *An Awfully Big Adventure*, performed at the Liverpool Playhouse in 1992. Her youngest daughter Rudi played the role of Stella. Beryl did not

feel able to state in her article what a good actress she thought her daughter was, but this was her opinion, later confirmed by the theatre director Jonathan Miller.

In other reviews Beryl expressed her affection for writers such as Dickens and Priestley, and made iconoclastic remarks about the classics. Of the character of Macbeth she writes, 'quite a harmless chap until the witches cackled out their prophecies'.[6] Or Lear: 'What daughter would want...to take in a dad who insisted on bringing along a retinue of 100 souls?'[7]

The intervals offered Beryl a further source of pleasure: she could have a ciggie and eavesdrop on comments from other members of the audience. On one such occasion, in early spring 1994, I told her off for smoking – in no uncertain terms and quite loudly – in the foyer of the Albery Theatre (now the Noël Coward Theatre), London. We were attracting attention, and she asked me to speak softly in case people thought we were a lesbian couple having a quarrel. She resented my interference and bore a grudge for months. She eventually wrote to turn down an invitation to spend some time with us: 'The thing is, since you threw that wobbler in the foyer of the theatre showing *A Month in the Country*, I'm wary of you.'[8]

Among the various comments made by the audience, she particularly enjoyed those of her grandchildren: Charlie commented on Tennessee Williams's *The Glass Menagerie*: 'Families...of course they didn't have the internet.'[9] Four-year-old August was so carried away by a performance of *Cinderella* that he shouted out that he wanted to marry the heroine. Beryl comments on his enthusiasm: 'Two hundred years ago this sort of emotional reaction was commonplace at Drury Lane.... We have become awfully silent in the interim. Awfully well behaved.'[10]

In December 1997, she decided to attend a series of lectures organized by the Royal College of Surgeons instead of reviewing a traditional pantomime. She certainly found it fascinating – she was always interested in medical books, and was particularly keen to hear the lecture on surgery during the Crimean War, as she was in the process of writing *Master Georgie*. In that context she reports on the most tragic statistics of deaths and amputations, as described at the lecture, and concludes, tongue in cheek: 'All in all it was a fun night out.'[11]

Beryl continued to write reviews for *The Oldie* long after the publication of *Front Row*. On occasion, she sent in reviews of plays even when

they were no longer in performance; but they were still published and made for a good read. In 2009 I saw *The Power of Yes*, David Hare's play on the 2007 recession in the UK, and I gave Beryl the programme, telling her that I hadn't understood a word: 'No point in my going, then,' she said. 'I will just write the review,' which also turned out to be a good read!

One of the final articles in the book is dedicated to Chekhov's *Three Sisters*, a play that she describes as lacking in plot. Chekhov's genius, she adds, lies in his ability to dramatize the ordinary. At the play's end we are meant to 'find out why we live, why we suffer' – as Beryl quotes from the play. 'Alas,' she adds, 'like me, I expect you are still waiting.'[12]

<div align="center">*</div>

At the end of summer 2005, Beryl called while I was holidaying in France to tell me she had cancer. 'Where?' I asked. 'In the breast,' she answered softly. Apparently her friend Parvin, the wife of Doctor Michael Laurence, had given her a hug and felt a lump on the side of her breast; she advised Beryl to have it examined. I did not know the Laurences at that time but Beryl had turned to Mike, an orthopaedic surgeon, to answer her frequent questions about medicine and disease, which so fascinated her, and spoke with affection of Parvin (who is Persian), describing her as a 'nice foreigner'.

Beryl took her diagnosis and mastectomy (which she called the 'amputation') well, almost with bravado: she saw it as a fact of life. I remember that she held some contempt for the fuss that Ruth Archer made about her mastectomy in episodes of *The Archers*. In an extract from the 'Ambridge Gazette' she wrote:

> I am beginning to lose patience with Ruth, she of the
> vanished breast...dedicated to the chopping off of the balls
> of sheep, dipping them in chemicals and administrating
> horrific drugs to pigs in...foal or whatever the term is.[13]

Beryl's operation was successful. She told me that at one of her check-ups she asked the consultant: 'Why don't you take the other one out as well? It will be more symmetrical and I will go out flat-chested like a boy.'

<div align="center">*</div>

Before Beryl started her final, unfinished novel, *The Girl in the Polka-dot Dress* (2011), she had another book in mind related to the death of Lady Diana, Princess of Wales. The story was to contain an episode from Beryl's life. As a naive young woman she was briefly employed by an 'elderly gentleman' to act as his companion and drive him, which she duly did without a licence (she never had one). In the idea for the novel, a similar young girl is taken by her employer to Paris where – bewildered in the French capital and overwhelmed by the sounds of drills excavating the Pont d'Alma tunnel, site of the fatal crash in 1997 – she has a premonition of the tragic accident.

So in May 2005 we went to Paris on a research trip. We asked a taxi driver to take us from the Gare du Nord to the Ritz in the elegant Place Vendôme: he looked us up and down, and when we arrived at the hotel he had the cheek to keep the car running; he obviously thought that the Ritz was out of our league. Fortunately, I had booked rooms in the name of Dame Beryl Bainbridge and we were ushered in without so much as a raised eyebrow.

During our stay, we retraced Diana's last journey from the Ritz to the entrance of the Pont d'Alma underpass. We travelled on foot and when we reached the tunnel, Beryl stood at the entrance and suggested that I might go in ahead of her on the narrow pavement and report back about the site of the crash. 'Can you see the pillar?' she shouted. 'What does it look like?' I did see a pillar, which looked like any other pillar. I did not dare to go any further, with cars whizzing past at great speed.

Beryl chose not to write this novel, even though we had discussed it for some time. She had even decided that the girl in the unwritten story should be called Rose – the name she gave to the main female protagonist in *The Girl in the Polka-dot Dress*. The two Roses share certain qualities: both are immature and naive, yet perceptive and sensitive to their environment.

Beryl had also decided on Blake's famous poem as an epigraph for the unwritten novel:

O Rose thou art sick!
The invisible worm
That flies in the night,
In the howling storm,

Has found out thy bed
Of crimson joy:
And his dark secret love
Does thy life destroy.[14]

*

There was a long gap between the writing of *According to Queeney* and *The Girl in the Polka-dot Dress*. Those who were close to Beryl became acutely aware of her struggle to write and the personal agony that she suffered during those years. The public may have thought that she could dash off a novel with great facility. In reality, she scrutinized her work, rewriting the same page 'twelve times', if necessary, and balancing the sound of each and every word 'to make sure the stresses fall in the right place'.[15] But usually the words came and the pages slowly filled up. Not so after *According to Queeney*: the source seemed to dry up altogether, possibly due to ill health.

Philip and I suggested that she might try to paint again and perhaps this would unleash the creative vein, but she didn't seem to have the energy for painting either. She turned down an invitation to stay with us in France, saying that she had to start the new book. How many times had we heard her phrase, 'I'm going upstairs to work!'? In summer 2006 she writes:

> Am coming out of slough and despond at last. Got off
> hospital (my lungs gave out) and am now vindicated,
> meaning I was convinced it was just a virus. It was!...I have
> decided to go to Brighton for 3 days. For my summer hols.
> Posh hotel, swimming pools, junk shops. Then I'll start
> my book. Come back soon.... All will be well.[16]

In summer 2008 she did find the energy and time, despite poor health, to visit an old romantic friend – or occasional 'gentleman caller' in her words – who had been her solicitor and inspired the main character in *Injury Time* (see page 118):

> So I went to see him, miles away in Chelsea, and it was sad.
> He has Parkinson's, speaks with difficulty, is partially blind

and can't walk, sit or eat without help. His wife is a saint. She is years younger and good-looking. She says her duty is to look after him and the cats, one of whom is not well. It was an odd day.

In that same year Beryl did spend some time with us in France; it was to be her last visit. She was no longer the ardent sun worshipper who would lie on the terrace under the rays of the Provencal sun, tanning her elegant body. She wore a big straw hat to hide her face and kept in the shade, occasionally dipping in the pool, using a rubber ring to float in the water. The usual cigarette hung from her mouth.

On her return, she wrote: 'Funny coming back. I kept waking up and thinking I was in your house in Provence.... I'm now ready to work. My holiday with you both was so good.' She goes on to discuss Philip's work and wonders about the effect that sexuality has on the creative process:

> I wonder if an ability to stay focussed is down to masculinity. I mean women losing their oestrogen lose their ability to remain creative. Men may lose a little something or other, but not the creative urge, which I believe is primarily sexual. Women's hormones just evaporate. Mine have, owing to the wretched pills I'm taking to banish cancer tumours.

The letter ends with an appeal to our friendship and a memory of earlier days together: 'We go back a long way – ever since that casserole Rudi was bathed in. Do you remember the midwife's name – I can't forget it – Bormann, Hitler's best friend?'[17]

<p style="text-align:center">*</p>

In an article about the assassination of Robert Kennedy in the *Los Angeles Times* of 6 June 1968, staff writer Dorothy Townsend noted that 'a girl in a white dress with polka dots ran out of the hotel where the Senator was shot'. Beryl was captivated by that detail and based her final novel on the dress: she takes the image as inspiration and develops a quest novel. Rose, the main protagonist in *The Girl in the Polka-dot Dress*, is from England, and has joined Harold, an American, in the States: they intend to drive across

The polka-dot dress in the shop window of Blustons,
which inspired the title of her final novel

the continent looking for a certain Doctor Wheeler (also American). Rose, who is about thirty and had been living in Kentish Town in London, first met Doctor Wheeler in Liverpool when she was young: he became a significant figure, almost mythic in her memory. Harold is using her to find Doctor Wheeler; we eventually discover that he plans to take revenge after Wheeler's affair with his wife, who committed suicide. In a letter to Harold before starting out for the States, Rose announces that she has bought a polka-dot dress for the journey. She wears this dress in the final scene and Harold pays her a compliment.

There is an old-fashioned shop on the Kentish Town Road, London, called Blustons, not far from where Beryl lived. The shop, which sells traditional women's clothing and outfits for special occasions, has been there seemingly forever. With the old-style lettering of the shop-front signage, it has the air of a 1950s department store. Beryl was intrigued by this mysterious shop, which must have reminded her of the shops from her youth in Liverpool. Above all, she was captivated by the window display featuring a beautiful halter-necked polka-dot dress, in the style of Marilyn Monroe. No matter what the season, the dress is always there. We stopped to look at it many times and Beryl once went in to ask the price.

Reading about Rose is like meeting an old friend, not just because she is like Beryl but because of the many similar characters encountered in the earlier novels. Like Stella in *An Awfully Big Adventure*, Rose has a vivid, almost morbid imagination. She imagines a mother, who has just buried her son, whispering into the family dog's ear that 'its childhood friend was never coming back.... The images in Rose's mind were so clear that tears stung in her eyes.'[18] Beryl has recovered her early voice in the character of Rose, who is innocent, yet uncannily shrewd and can see through surface appearances. In a review of the book, A. N. Wilson wrote, 'Beryl's genius was that of the knowing child looking into the world of the grown-ups.'[19]

Rose's childhood memories are also familiar to readers: her mother spends the evening in a train station waiting room to escape from tension at home, as in *A Quiet Life* (see page 116); as a young girl, Rose peeps through the window at the Wheelers as they make love, which is reminiscent of a scene in *Harriet Said*. A stuffed owl 'in a glass case'[20] features in the

dining room of Harold's friends, the Shaefers; Beryl had just such an owl on display in her home.

Harold's reaction to Rose (including her frequent references to 'homely memories' and the 'Holy Spirit' and the 'Day of Wrath') alternates between having to stop himself from giving her a slap because he considers her 'a retard', and finding her presence 'unsettling'. In his view, she is 'too confrontational, too apt to speak without thinking'. [21]

Finally, 'that bloody book', as Beryl liked to call *The Girl in the Polka-dot Dress*, took shape after years of planning and contemplation. She studied the geography of the States: fortunately, she could refer to the journal she kept in 1968 when she travelled in a campervan with Harold Retler (see page 70). The scheme of the novel had been there in embryo when she speculated in that same journal on the possibility of writing about a journey; she planned to give it the title *The Idyll*. And she returned to the sequence of political events leading up to the American presidential primary elections of that year, to add to the background of the novel. Beryl included Robert Kennedy's assassination in the narrative by making Wheeler part of Kennedy's entourage. She even considered a scene in which Rose accidentally involves herself in the assassination, but she obviously decided against including this plot device in the novel.

<p style="text-align:center">*</p>

Long before the end, Beryl's bad health began to take its toll. She was never particularly interested in food, but she hardly remembered to eat in her last years. Once beautifully slim, she began to look emaciated. Her appetite had gone – even for the beloved fish and chips or plate of curry, which she used to eat with so much relish. She began to leave her food untouched in restaurants, apologizing to the waiting staff for fear of offending. Philip tried to tempt her with oysters and escorted her to the oyster bar in the newly restored St Pancras station. She did her best to share a dozen with him and enjoyed the occasion.

Afterwards Beryl returned home to write a few more lines, one more page.... Until she couldn't any more. She has left us an open-ended novel based on a journey, the metaphor for the introspective search for the self: "'We are all looking for something," says Harold. "Or *someone*,"

answers Rose.'[22] And so the novel ends, but is inconclusive because, by definition, the quest is eternal, and of course Beryl died before its completion. What a perfect way to end her writing career, leaving the reader wondering if she ever found what she was looking for. The novel seems to answer, 'no'.

<p style="text-align:center">*</p>

We talked about death – 'the end' – from time to time. Beryl envisaged a bed surrounded by the family, kneeling and weeping around her, like a romantic painting. As for her funeral, she jokingly pictured a coach with black horses, plumage and all. In fact, she had made serious arrangements for her service and gave instructions to Father Graeme, who was to officiate.

When Beryl's cancer reappeared and spread, her main response was, 'Must finish this bloody book!' At the hospital her doctors were 'consulting', unable to decide on the best course of treatment. 'They are useless,' she complained to me, and added defiantly, 'Honestly, English hospitals nowadays...I might as well die.'

I went in to see her as often as I could. Her children were usually there, and so was Michael Laurence, standing by her bed. This is where we first met, although Beryl had talked to me about him, and I loved him for this act of friendship. The children had arranged for her to listen to her favourite songs, and beside her bed was *Dover Beach and Other Poems,* by Matthew Arnold, so she could read the poems she most loved.

One morning, when I couldn't go in, I called Jojo on her mobile. I could hear Beryl's voice, strong and excited, in the background. Brendan was there and she was giving him instructions about the final chapter of the 'bloody book'. The next morning, Jojo called: 'She is dying'.... O Rose....

The end came in the night with the children by her side. The funeral ceremony was held according to the traditional Catholic rites as she had requested, and was attended by hundreds of people – close family and friends, including among others Terry Waite, Melvyn Bragg, Mark Lawson and A. N. Wilson and even Mr Howard, her hairdresser from Bishop's Stortford. Tall and handsome, four of her grandsons carried the coffin in

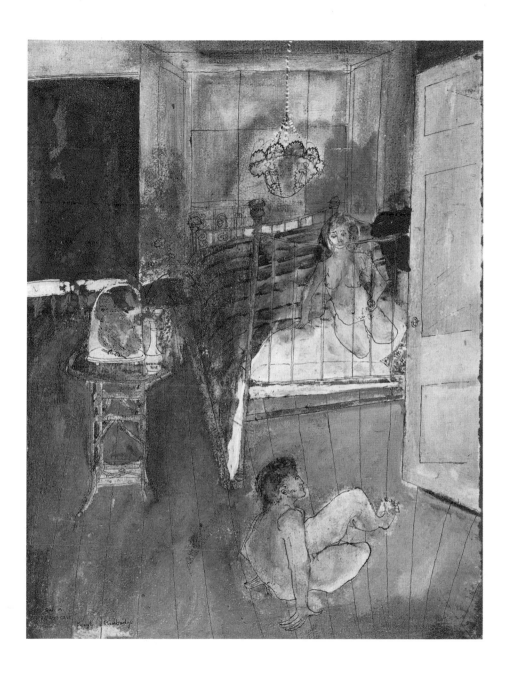

Owl in a Glass Case, date unknown

and out of the church. The burial, at her request, took place in the ancient Highgate Cemetery, north London, green with trees and bushes, where so many famous artists and writers are buried. There we sang 'Two Little Boys' at her request. The wake was held at the home of Michael and Parvin Laurence. Sumptuous food was set out on a large table: in the corner, a fried egg, half a glass of whisky and a cigarette. Parvin explained: 'That's for Beryl.'

EDITIONS CITED

A Weekend with Claud, London, Hutchinson (New Authors Limited), 1967

Another Part of the Wood, London, Hutchinson & Company, 1968

Harriet Said, London, Duckworth, 1972

The Dressmaker, London, Duckworth, 1973

The Bottle Factory Outing, London, Duckworth, 1974

Sweet William, London, Duckworth, 1975

A Quiet Life, London, Duckworth, 1976

Injury Time, London, Duckworth, 1977

Young Adolf, London, Duckworth, 1978

Winter Garden, London, Duckworth, 1980

Watson's Apology, London, Duckworth, 1984

English Journey: or The Road to Milton Keynes, London, Duckworth, 1984

Mum and Mr Armitage, London, Duckworth, 1985

Filthy Lucre, London, Duckworth, 1986

Forever England: North and South, London, Duckworth, 1987

An Awfully Big Adventure, London, Duckworth, 1989

The Birthday Boys, London, Duckworth, 1991

Something Happened Yesterday, London, Duckworth, 1993

Every Man for Himself, London, Duckworth, 1996

Master Georgie, London, Duckworth, 1998

According to Queeney, London, Little, Brown & Company, 2001

Front Row: Evenings at the Theatre, London, Continuum, 2005

The Girl in the Polka-dot Dress, London, Little, Brown & Company, 2011

NOTES

Preface, pages 7–16

1 Carol Price, 'The art of the novelist', *Sunday Times Magazine*, 27 October 1985.
2 The original 1967 title was *A Weekend with Claud* (Hutchinson). Beryl Bainbridge revised the spelling of Claud to Claude for the revised and partially rewritten edition published in 1981 by Duckworth as *A Weekend with Claude*.
3 Shusha Guppy, 'Beryl Bainbridge, The Art of Fiction', *The Paris Review*, No. 157, 2000.
4 Nicholas Wroe, 'Filling in the Gaps', *The Guardian*, 1 June 2002.
5 Alex Hamilton, 'Enough to go on with', *The Guardian*, 29 November 1974.
6 'Beryl Bainbridge, novelist, painted a drama that happened to herself', *Sunday Times Magazine*, 17 February 1980.
7 Ibid.
8 John Wakeman (ed.), 'Bainbridge, Beryl (Margaret)', *World Authors*, New York, H. W. Wilson Co., 1980, p. 49.
9 Bainbridge, *Forever England*, p. 31.
10 Ibid., p. 15.
11 Bainbridge, 'My father would rant and rave for weeks – but he was still superior', *Daily Mail*, 9 February 2008.
12 Bainbridge, *Forever England*, p. 26.
13 Shusha Guppy, 'Beryl Bainbridge, The Art of Fiction', *The Paris Review*, No. 157, 2000.
14 'The Writing Life: Beryl Bainbridge', *Writer's Digest*, June 1999.
15 Lynn Barber, 'Beryl's Perils', *The Observer*, 19 August 2001.
16 'Beryl Bainbridge, novelist, painted a drama that happened to herself', *Sunday Times Magazine*, 17 February 1980.
17 Alex Hamilton, 'Enough to go on with', *The Guardian*, 29 November 1974.
18 Carol Price, 'The art of the novelist', *Sunday Times Magazine*, 27 October 1985.
19 'Beryl Bainbridge, novelist, painted a drama that happened to herself', *Sunday Times Magazine* (17 February 1980).
20 Bainbridge, *Forever England*, p. 119.
21 Carol Price, 'The art of the novelist', *Sunday Times Magazine*, 27 October 1985.
22 Ibid.
23 Ibid.
24 Ibid.
25 Ibid.

Introduction, pages 19–40

1 Obituary, *The Daily Telegraph*, 2 July 2010.
2 Bainbridge, *English Journey*, p. 184.
3 Bainbridge, *Mum and Mr Armitage*, p. 11.
4 Lynn Barber, 'Beryl's Perils', *The Observer*, 19 August 2001.
5 Bainbridge, *According to Queeney*, p. 201.
6 Bainbridge, *Filthy Lucre*, p. 7.
7 Ibid.
8 Ibid., p. 8.
9 Ibid., p. 13.
10 Ibid., p. 16.
11 Ibid., p. 24.
12 Letter to the author, July 1998.
13 A. N. Wilson, *Camden New Journal*, 30 June 2011.
14 Bainbridge, *English Journey*, pp. 88–89.
15 Bainbridge, *Something Happened Yesterday*, p. 136.
16 Both citations: Bainbridge, *English Journey*, p. 90.
17 Ibid., p. 89
18 Ibid., p. 84.
19 Phone conversation, May 2011.
20 All citations, letter to the author, 2 June 2011.
21 Letter to the author, September 2011.
22 Letter to the author, June 2011.
23 Letter to the author, June 2011.
24 Letter to the author, July 2011.
25 Letter to the author, August 2011.

26 Carol Price, 'The art of the novelist', *Sunday Times Magazine*, 27 October 1985.

27 Letter to the author, November 2000.

Chapter 1, pages 41–65

1 All citations, letter to the author, June 2011.

2 Bainbridge, *Sweet William*, p. 60.

3 Ibid., p. 159.

4 Letter to the author, June 2011.

5 Lynn Barber, 'Beryl's Perils', *The Observer*, 19 August 2001.

6 Bainbridge, *A Weekend with Claud*, p. 174.

7 Ibid., p. 181.

8 Ibid., p. 101.

9 Ibid., p. 68.

10 Ibid., p. 18.

11 Ibid., p. 185.

12 Ibid.

13 Ibid., p. 42.

14 Letter to the author, September 2011.

15 Letter to the author, June 2011.

16 Letter to the author, May 2011.

17 Letter to the author, May 2011.

18 Bainbridge, *Every Man for Himself*, p. 158.

Chapter 2, pages 66–101

1 Letter to the author, March 2011.

2 Letter to the author, October 1995.

3 Letter to the author, July 2011

4 Letter to the author, January 2012.

5 Bainbridge, private journal, June 1968.

6 Ibid., all citations.

7 Ibid.

8 Letter to the author, April 2011.

9 Letter to the author, March 2011.

10 Letter to the author, August 2011.

11 Letter to the author, September 2011.

12 Ibid.

13 Letter to the author, April 2011.

14 Letter to the author, August 2011.

15 Letter to the author, June 2011.

16 Interview with the author, October 2011.

17 *Camden New Journal*, 8 July 2010.

18 Letter to the author, September 2011.

19 Letter to the author, August 2011.

Chapter 3, pages 102–29

1 Letter to the author, September 2011.

2 Conversation with the author, September 2011.

3 Bainbridge, *Harriet Said*, p. 38.

4 Ibid., p. 36.

5 Ibid., p. 31.

6 Ibid., p. 74.

7 Ibid., p. 154.

8 Bainbridge, *The Bottle Factory Outing*, p. 12.

9 Ibid., p. 28.

10 Ibid., p. 108.

11 Ibid., p. 122.

12 Ibid., p. 129.

13 Fax to the author, July 2003.

14 Letter to the author, August 2003.

15 Bainbridge, *The Bottle Factory Outing*, p. 52.

16 Bainbridge, *A Quiet Life*, p. 17.

17 Ibid., p. 76.

18 Ibid., p. 136.

19 Ibid., p. 43.

20 Ibid., p. 11.

21 Ibid., p. 5.

22 Ibid., p. 6.

23 Ibid., p. 8.

24 Ibid., p. 155.

25 Bainbridge, *Injury Time*, p. 66.

26 Ibid., p. 75.

27 Bainbridge, *Winter Garden*, p. 7.

28 Ibid., all citations, p. 157.

29 Ibid., p. 10.

30 Bainbridge, *Mum and Mr Armitage*, p. 132.

31 Ibid., p. 135.

32 Letter to the author, July 1985.

33 Letter to the author, August 2002.

34 Bainbridge, *Young Adolf*, p. 39.

35 Ibid., p. 157.

36 Ibid., p. 120, both citations.
37 Ibid., p. 172.
38 Ibid., p. 72.
39 Ibid., p. 174.
40 *The New York Times*, 24 April 2006.
41 Letter to the author, April 1982.
42 All previous citations in this paragraph: letter to the author, August 2011.
43 Letter to the author, September 2011.

Chapter 4, pages 130–59

1 Bainbridge, *Watson's Apology*, p. 72.
2 Ibid., p. 10.
3 Letter to the author, November 2011.
4 Ibid.
5 Bainbridge, *An Awfully Big Adventure*, p. 18.
6 Ibid., p. 171.
7 Ibid., p. 186.
8 Ibid., p. 99.
9 Ibid., p. 192.
10 Bainbridge, *The Birthday Boys*, p. 179.
11 Huntford, Roland, *Scott & Amundsen: The Race to the South Pole*, London, Hodder & Stoughton, 1979.
12 Ibid., p. 127.
13 Ibid., p. 39.
14 Ibid., p. 150.
15 Ibid., p. 109.
16 Ibid., p. 111.
17 Ibid., p. 111.
18 Ibid., p. 114.
19 Scott's correspondence, Scott Polar Research Institute archives, Cambridge.
20 Bainbridge, foreword to *Scott's Last Journey*, (ed., Peter King,), London, Duckworth, 1999, p. 10.
21 Telephone conversation, 23 September 2011.
22 Father Graeme Rowland, funeral speech, 12 July 2010.
23 Bainbridge, *Something Happened Yesterday*, pp. 7–8.
24 Ibid., p. 37.

25 Ibid., p. 80.
26 Ibid., p. 46.
27 Ibid., p. 24.
28 Ibid., pp. 117–18.
29 Ibid., p. 67.
30 Ibid., p. 31.
31 Ibid., p. 64.
32 Ibid., p. 143.

Chapter 5, pages 160–85

1 Letter to the author, August 1993.
2 Lynn Barber, 'Beryl's Perils', *The Observer*, 19 August 2001.
3 Bainbridge, *Every Man for Himself*, p. 10.
4 Ibid., p. 204.
5 Ibid., p. 165.
6 Ibid., p. 178.
7 Letter to the author, May 2011.
8 Bainbridge, *Every Man for Himself*, p. 211.
9 Ibid., p. 212.
10 Fax to the author, September 2002.
11 Ibid.
12 Bainbridge, *Master Georgie*, p. 162.
13 Ibid., p. 190.
14 All citations: ibid., pp. 186–87.
15 Fax to the author, April 2003.
16 Ibid.
17 Lynn Barber, 'Beryl's Perils', *The Observer*, 19 August 2001.
18 Letter to the author, April 2000.
19 Ibid.
20 Letter to the author, July 2000.
21 Letter to the author, August 2000.
22 *Camden New Journal*, 23 November 2000.
23 Bainbridge, *According to Queeney*, p. 15.
24 Ibid., p. 38.
25 Ibid., p. 68.
26 Ibid., p. 167.
27 Ibid., p. 36.
28 All citations: ibid., p. 72.
29 Ibid., p. 175.
30 Letter to the author, June 2011.
31 Bainbridge, *Injury Time*, p. 79.
32 Fax to the author, 15 April 2003.
33 Fax to the author, August 1993.
34 Fax to the author, 15 April 2003.

Chapter 6, pages 186–98

1 Letter to the author, June 2011.
2 Bainbridge, *Front Row*, pp. 6–7.
3 Ibid., p. 145.
4 Ibid., p. 116.
5 Ibid., p. 113.
6 Ibid., p. 57.
7 Ibid., p. 66.
8 Letter to the author, August 1994.
9 Bainbridge, *Front Row*, p. 104.
10 Ibid., p. 160.
11 Ibid., p. 116.
12 Ibid., p. 202.
13 Letter to the author, July 2000.

14 From *The Oxford Dictionary of Quotations* (Third Edition), Oxford, Oxford University Press, 1979.
15 Lynn Barber, 'Beryl's Perils', *The Observer*, 19 August 2001.
16 Letter to the author, July 2006.
17 Letter to the author, August 2008.
18 Bainbridge, *The Girl in the Polka-dot Dress*, p. 91.
19 A. N. Wilson, *Camden New Journal*, 30 June 2011.
20 Bainbridge, *The Girl in the Polka-dot Dress*, p. 32.
21 Ibid., p. 100.
22 Ibid., p. 198.

ACKNOWLEDGMENTS

My first thanks go to Brendan King and to Beryl's family for all the help and information they have provided and for putting me right on several scores. I am equally indebted to my husband, Philip, who has been indefatigable in his support and advice, and to Julie Melrose who worked with him. Thanks also to those friends who have allowed their paintings by Beryl to be photographed for the purpose of appearing in the book. Finally, thanks to editor Helen Cleary and the staff of Thames & Hudson, so friendly and cooperative.

Photograph p. 103 courtesy of Sarah Taylor, Simon Hancock and Jamie Camplin.

Note on titles and dates

Beryl Bainbridge only occasionally gave titles to her paintings and drawings, which have never been catalogued or published before. Dates are approximate.